Capture Your KIDS in PICTURES

Capture Your KIDS in PICTURES

Simple Techniques
for Taking
Great Family Photos
with Any Camera

Jay Forman

Amphoto Books

an imprint of WATSON-GUPTILL PUBLICATIONS / NEW YORK

ACKNOWLEDGMENTS

I am embarrassed that mine is the only name listed on the front of this book. I could no more have written this alone than a coach could win the Super Bowl without players. It just isn't possible. I am grateful for the endless support and influence of my friends and family. To Ginger Garrett, you're the upperclassman that taught this freshman how to swagger down the senior hall. You're a real talent. To Lee Forman, for my first "exposure."

Angie, Brian, and Kasey, thanks for letting some noodles stick—and being honest enough to tell me when some needed to fall. Carl and Mary Nell Christianson, thanks for the tutelage and, especially, for the contacts. My experience at Details was an undeniably strong influence. Thanks Brian and Jesse. Sandra O., I think of your intuition to this day. To Thomas Kenny, thanks for teaching this peep that the climb is as thrilling as the summit. There but for you go I.

To all the parents who allowed their kids to be photographed for and featured in this book, you have my sincerest thanks for trusting me to be responsible with your children's images. I hope your families have enjoyed the process. To the remarkable editorial, design, and production team at Watson-Guptill Publications and pink design, inc.—you can't possibly know how appreciative I am of how you embraced and cultivated my vision for this book.

To my wife, Sandy, thank you for giving me the time away from home so that I could get the work done. You never complained (lie!), but supported every inconvenience and loopy idea with reassuring confidence. There are people that gave of themselves on this book simply because of you and despite me. And finally, to my sons, thanks for sharing your daddy with other children for these long months. I'm all yours.

SENIOR ACQUISITIONS EDITOR: Victoria Craven
SENIOR DEVELOPMENTAL EDITOR: Alisa Palazzo
DESIGN: pink design, inc.
PRODUCTION MANAGER: Hector Campbell

Text and photographs © 2004 Jay Forman

First published in New York in 2004 by
Amphoto Books, an imprint of Watson-Guptill Publications,
a division of VNU Business Media, Inc.
770 Broadway
New York, NY 10003
www.watsonguptill.com
www.amphotobooks.com
www.captureyourkidsinpictures.com

Library of Congress Cataloging-in-Publications Data
Forman, Jay.
 Capture your kids in pictures : simple techniques for taking great family photos with any cameras / Jay Forman.
 p. cm.
 ISBN 0-8174-3655-3 (pbk.)
 1. Photography of children. 2. Photography of families. I. Title.
 TR681.C5F68 2004
 778.9'25--dc22

 2003023843

Printed in Singapore

1 2 3 4 5 6 7 8 9 / 12 11 10 09 08 07 06 05 04

Preface

I still remember the day I bought my first nice camera. My new enthusiasm for taking pictures rivaled that of any venture I'd ever tried. I shot three rolls of film at my child's soccer game, took twenty photos of my infant son taking a nap, and . . . well, you get the idea. Only when my zeal started to assault my bank account did I back off a little. It's a good thing, too, because upon closer inspection, my pictures were—in a kind word—lacking. The best thing I could say about them was that you could, at times, recognize the people in them.

I wanted to improve my skills but couldn't get past the same mundane results: cropped-out ears, out-of-focus eyes, stale composition. I kept asking myself, "What is that elusive element that makes a picture special? What is the magic in a photo that captivates us?" If you're looking to answer these questions and want better pictures of your kids, this book is for you.

As a parent, you have the best opportunities to photograph your children since you are with them at birthdays, Christmas, Halloween, ball games, graduations, and everything in between. And while school or studio photos are great for documenting each passing year and hairstyle, they usually fall short in capturing a child's true personality. I doubt your kids enjoy spending the day dressed in their Sunday best, pasting their hair into submission, and sitting still while a studio pro fiddles with a camera; they're not at ease and, therefore, won't be themselves when you really want them to.

When taking photos of your kids, you want to capture their precious spirit and the subtleties in their personalities. The half-grin of my three-year-old is distinctly more mischievous than when he was two and a half. My seven-month-old son's eyes were a chip off my block just a month ago, but now they're unmistakably identical to my wife's. Parents embrace the different stages of their children's growth, and want to freeze each moment in time before it evaporates into the next stage and is lost. Indeed, our kids do grow up too quickly, but photos allow us to snag a moment so that we can revisit it as often as we like. It makes their growing up, and our growing old, bearable.

With just a few basic tips on understanding photography—and children—you can transform your picture-taking so that it yields consistently good results. Taking great family photos doesn't require expensive gear or technical prowess, just the practical application of simple principles and some common sense. These principles are geared to increase your chances of having more keepers per roll, thus helping to build a photo album of which you can be proud. At the very least, you've spent quality time with your child.

To demonstrate that simplicity can be effective, I took every photo appearing in this book with a standard 35mm camera and a basic flash or just sunlight. No high-tech studio tricks here! After all, you're probably not interested in a career change, nor do you have unlimited funds to purchase expensive gear. But, you do want to finally get some great photos of your kids before they grow up. It is my hope that this book will help you do just that.

contents

Part One
Learning to See

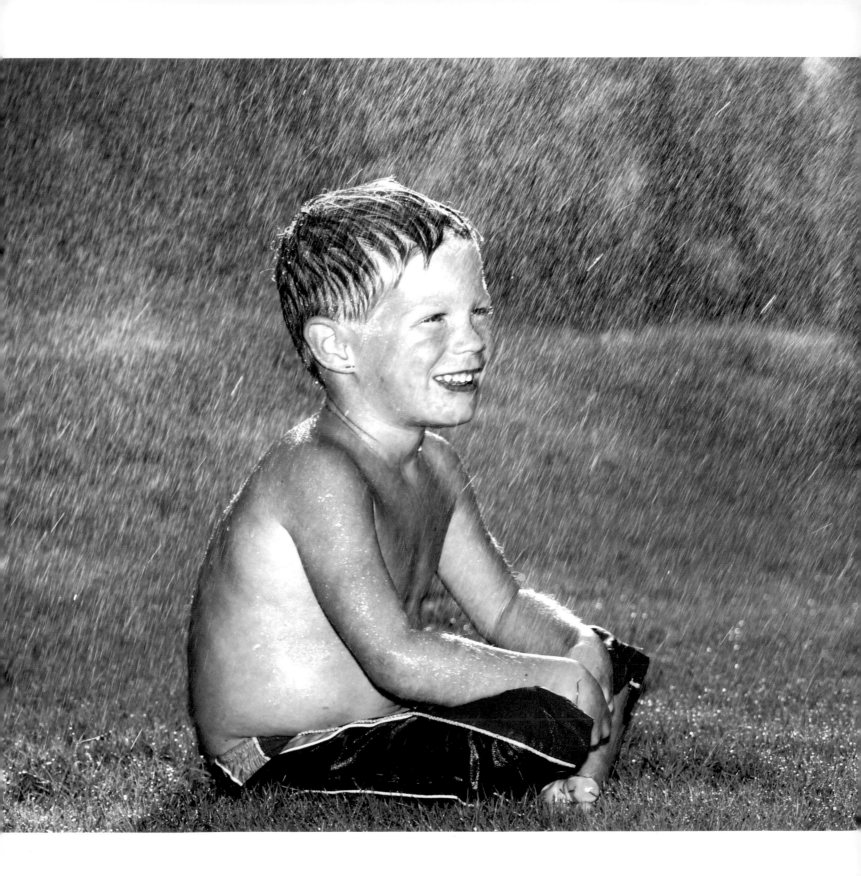

Composition

Composition is probably the least emphasized—yet one of the most important—aspects of a photograph. How you frame your child will ultimately determine how interesting the finished photo is. There are many elements to consider, so where do you start? Review the tips that follow, and then start by employing just one or two. Analyze the photos closely for what works and what doesn't. When you feel good about the results you're getting, continue practicing with another one or two tips. It won't be long before you start getting striking photos that please your eye and captivate your attention.

▸▸ Get Closer

If you glean nothing else from this book, follow this one simple mandate: To take better photos of your children, get closer to them than you ever have before. It's that simple. There's no wacky algorithm, no intricate process, no magic word. Just take several steps closer to your kids and start shooting. Too often, we take a picture that includes our subject, but also a host of other nonessential elements. Think about it, do you really want that table, couch, tree, or car in the background? Do you really need all that extra space around your child? Moving closer results in a much more intimate picture of your child.

 Practice getting close by standing at your customary distance from your child and snapping a picture. Then take two steps closer, and take another shot. Do it again until you're two feet from your child. Find out how close your camera will let you get while staying in focus, then stay in that range. Using a zoom lens is also very effective as it allows you to get closer without encroaching on your child's personal space. Look at the results when you get the pictures processed, and see for yourself how close-up shooting yields the most personal, beautiful pictures of your kids.

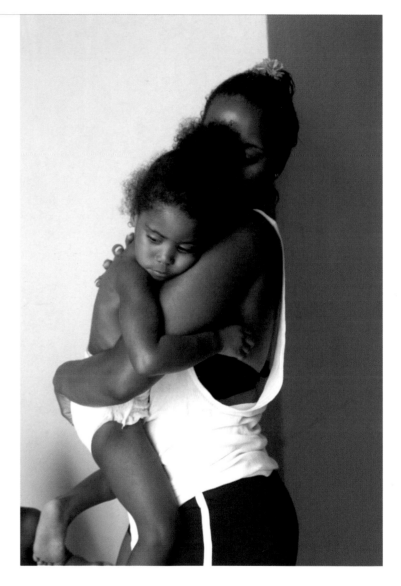

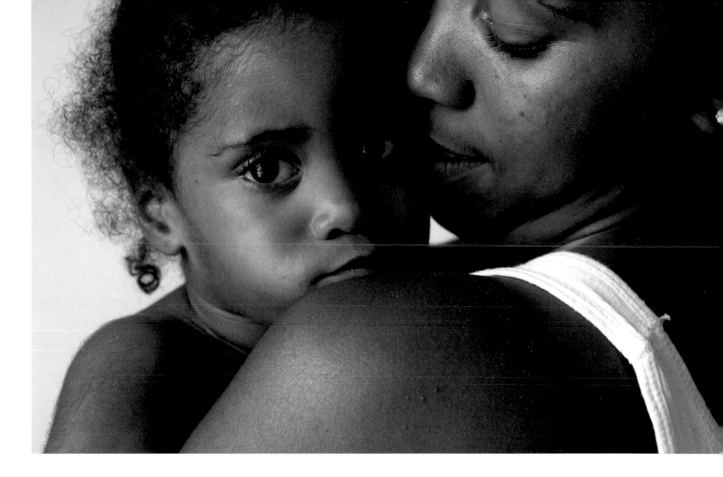

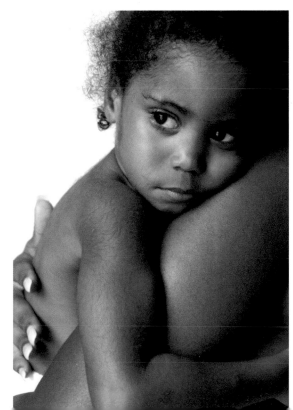

This grouping is a great example of how to overcome mediocre elements to get a great picture. The photo opposite shows all the unimportant elements: the less-than-casual clothes, the very drab wall. Move closer, and suddenly those distractions disappear and leave us with two portrait-quality pictures of this little girl.

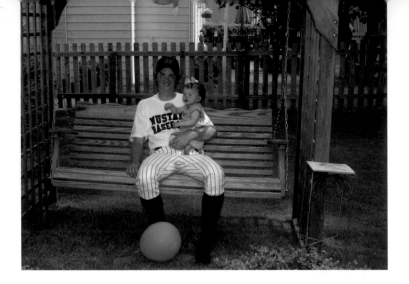

Moving closer results in a much more intimate picture of your child.

The image above illustrates the typical approach many parents have to taking pictures of their kids. The photographer is so far away from the subject that there's uncertainty as to what the subject actually is. Maybe the photographer makes wooden swings and wants to show a family that's pleased with the product. Maybe this is a picture of balloons or even small beverage tables. Moving closer (right) removes all the distracting elements, and lets the viewer enjoy the relationship between the teenage ballplayer and his baby sister.

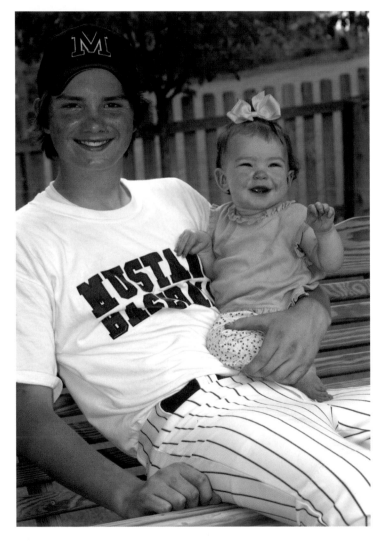

Three's a crowd in this picture of a girl, her dog, and the lawn chair (below). As cute as the girl and dog are, the white of the lawn chair is a fierce competitor for your eyes. Simple cropping gives this picture new life by completely removing the chair from the scene (right). Now the two subjects are best buds, merging so that the viewer isn't sure where the girl ends and the dog begins. Post-process cropping can help save a poor photo, but it does result in the reduced sharpness you see here. A better choice is to just get closer to the subject.

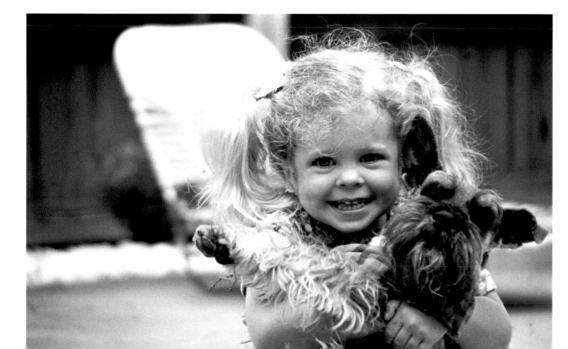

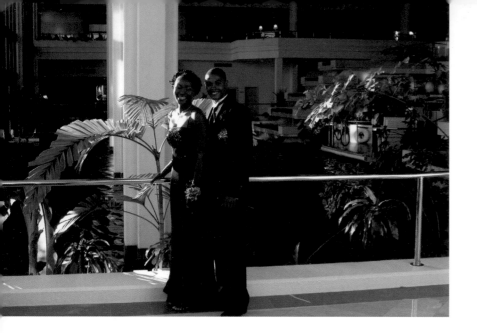

Close-up shooting yields the most personal photos of your kids.

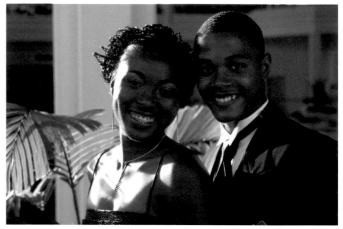

Photographing this prom couple afforded the opportunity for several choices. In the photo above, I clearly needed to move closer. But how close is too close? There may be more than one right way. Prom is a time where the elegant attire and venue are important to the occasion, so you don't want to lose too much of that, as in the photo at right. Getting close is good, but remember to include environmental accoutrements when they're appropriate.

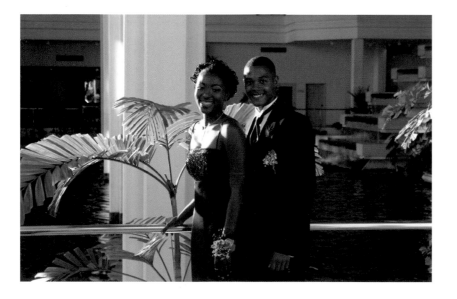

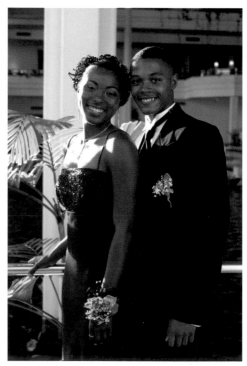

CHOOSING YOUR SUBJECT

It's pretty easy to zero in on a child playing with a dollhouse or a teenager practicing guitar. They're alone, so it's clear to see where the "action" is. But what happens when your child is mingling among ten others at a ball game, a birthday party, or the swimming pool? Suddenly there's chaos; the scene is muddled, and without some adjustment, chances are your photos will be, too.

Try to remember that within much activity, there are several independent events taking place. Sure, it may be a large birthday party, but there's also a game of tag between two kids, three more eating cake and laughing, and one crying over a scary clown. Try to break the big scene down into smaller ones, and focus on them individually. Think of yourself as a photojournalist getting to the core events that make up the big story. Those are the subjects that provide the warmest photos, full of the close-up details that make the party impossible to forget.

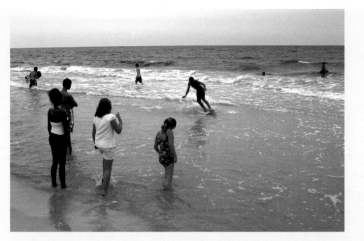

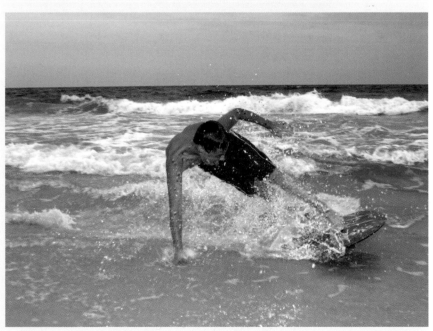

Try to determine the main subject of the top photo. The frame is expansive with no single event drawing your attention. If you're the parent of the boy on the skim board, you should move much closer and try to freeze his action (above). Will you get wet? A little. Will you melt? Nah. Will you go home with a memorable photo of your beach trip? Absolutely.

▸▸ The Rule of Thirds

Where you place your subject in the picture frame can make a photo exceptional or mundane. One way to find balance in your photos is to employ the Rule of Thirds.

When looking through the viewfinder, superimpose an imaginary grid over what you see that divides the frame both vertically and horizontally into thirds, thereby making three equal vertical and horizontal sections. This will give you nine sections of equal size and four points of intersection (where the grid lines cross over one another). The Rule of Thirds dictates that you place your subject at one of these four intersecting points.

Essentially, that means *don't center your subject.* Most people think analytically, as that's what's expected of us at the office or when balancing our checkbooks—we naturally default to symmetry, and though sensible, it's just not that interesting visually. Our eyes are drawn more to asymmetrical images than to symmetrical ones. Practice throwing your subject just off center (using the four grid intersection points as guides), and watch the image become arresting.

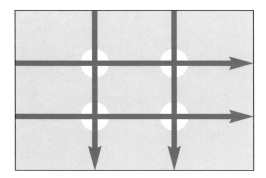

A grid that divides the picture frame into nine equal sections would look like this. When you turn your camera to make a vertical composition, just imagine the grid rotating, as well. Strive to keep your subjects at one of the intersecting points.

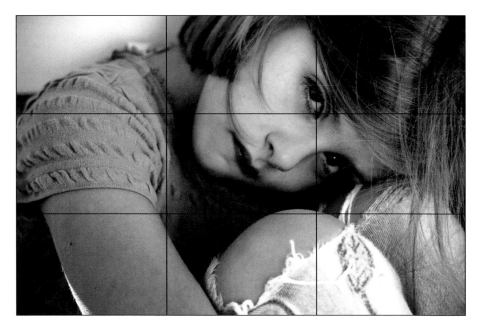

As an example, the imaginary Rule of Thirds grid has been superimposed over this image. The eyes fall off center—roughly on the upper right intersection point of the grid—and this makes the image more interesting, successful, and less typical than if the subject's face had been centered within the picture frame.

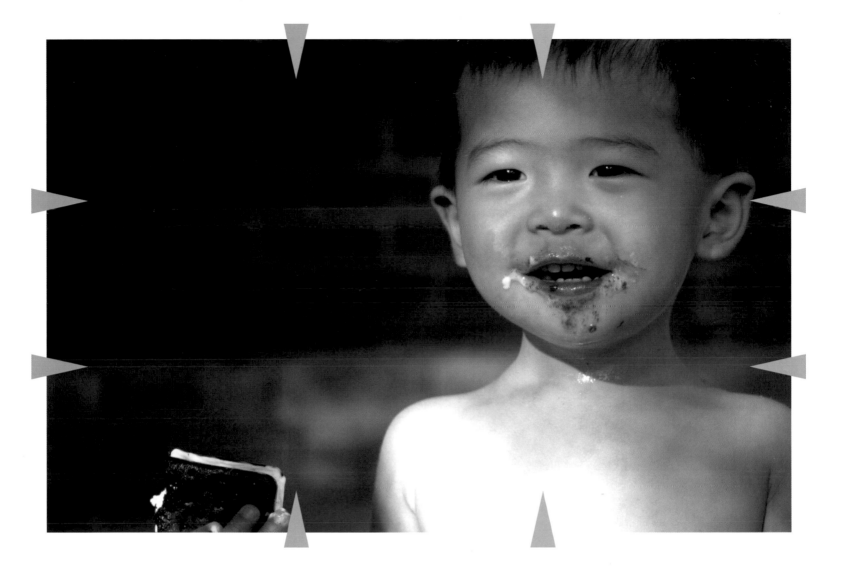

The image to the right shows the typical approach, with the child squarely in the center of the frame. It's a cute shot of the boy, complete with the familiar sticky ending most parents have experienced. Still, you sense his claustrophobia—as if he's jailed within the thick borders of the image. He's liberated above, but that wasn't an accident. While the boy was getting started with his ice cream, I changed his position in the frame several times to see which perspective looked best; then, as he started to interact with me, I had him framed where I wanted him and was able to snap the shutter at just the right time. (*Note:* The arrows at the edges of the image above indicate the Rule of Thirds grid.)

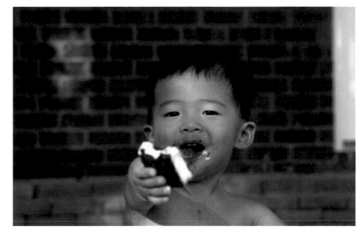

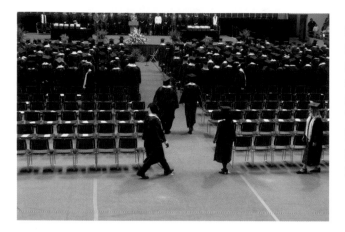

Sometimes it's easier to see the impact of a technique on a picture when two precious eyes are not staring back at you. The uniform lines of these graduating seniors help illustrate why it's important to throw the action off center. The first photo (left) centers the walkway in the composition, while the second (below left) places it at the bottom left. Which photo holds your eye longer?

Don't center your subject.

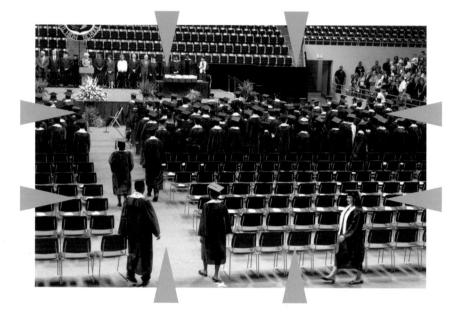

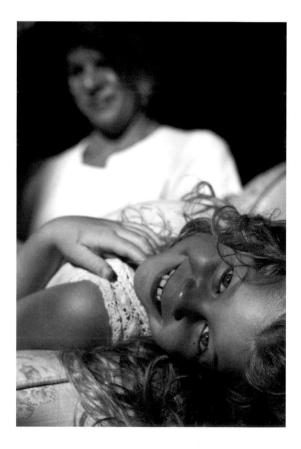

Our kids are anything but predictable, and this unpredictability can yield wonderfully creative pictures. Let them be their imaginative selves while you stand ready to grab the golden moments. This girl didn't feel pressured to pose, giving instead a glimpse into her point of view. Observing the Rule of Thirds and placing the girl in the lower section of the frame enabled me to include mom in the background, which helps to enhance the girl's reclining orientation.

Note: Your child's eyes will always be the main subject of your image, and that's especially true with a close-up. Accommodate the eyes in the frame and most everything else will take care of itself.

The elements in this scene are virtually identical, but the two photos are far from equal. The photo above centers the girl in the middle of the frame. As a consequence, the heavy red bench acts as a magnet for your eye and distracts from the real subject: the girl. The photo at right shifts the arrangement slightly, resulting in an image that is more balanced. The bench is now de-emphasized, and the girl becomes the anchor. The height of the IV stand and tree lends itself more to a vertical photo than a horizontal one. Due to their large size, these elements also drive home how young the girl is, which increases the emotional impact.

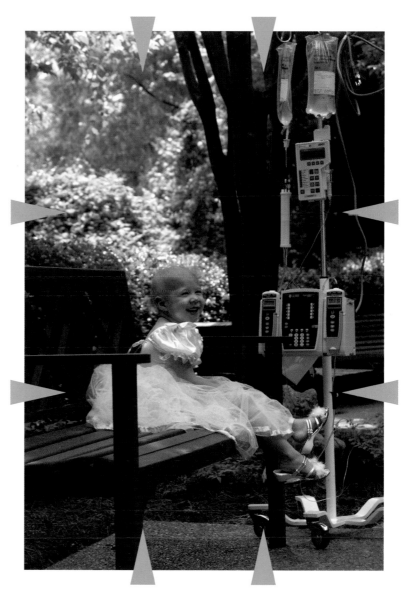

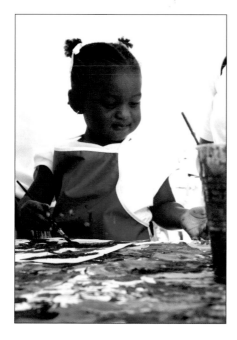

The Rule of Thirds enabled me to contain this girl completely in the activity. Had I centered her face in the composition, her father would have been a noticeable distraction in the top of the frame, and I would have lost all the wonderful art at the bottom. Positioned as she is, at the top, she's immersed in her work and the colorful pigment that is hopefully washable.

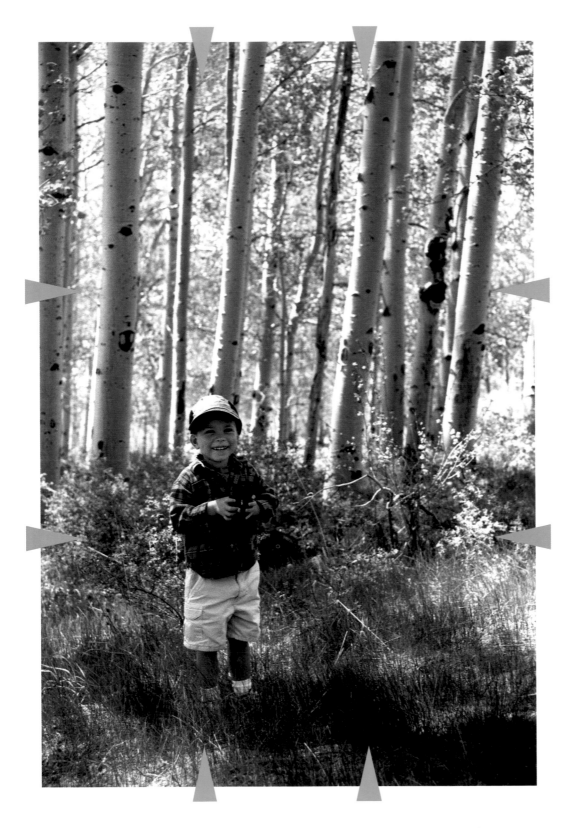

We may default to symmetry ... but it's just not that interesting to look at.

Notice how firmly this boy grips your eye. That's compelling when you consider that the Aspen trees take up most of the image. They're big and tall, but they clearly are not the subject. The Rule of Thirds off-center placement ensures that the trees play a supporting role, allowing the viewer to share the full wilderness experience with the boy without the trees overpowering him.

▸▸ Avoid the Mug Shot

When taking a close-up photo, find an angle that's somewhere between a straight-on mug shot and a profile. Straight-on shots appear cold, flat, and posed, whereas that slight tilt of the head makes the shot much more personable and candid—like you caught the subject off guard.

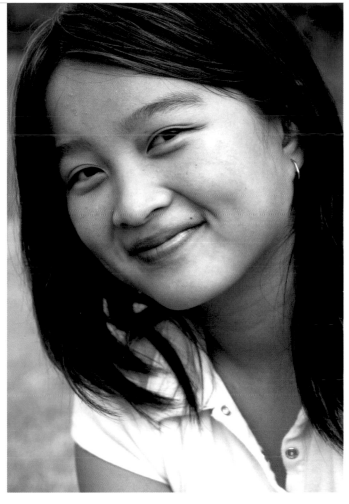

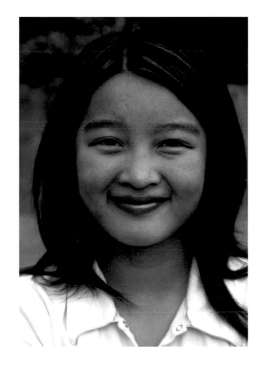

The face has wonderful undulating peaks and valleys, so capturing those landscapelike features in more of a three-quarter angle (left and top right) and adds depth and interest.

▶▶ Leave Room to "Look"

Space around the subject, especially in the direction the subject is looking, implies that there's more beyond the picture frame, and the fact that we can't see what it is engages our imagination and makes the photograph interesting. Take a minute to look at all the images in this section and note the balance that is created when the children's eyes have plenty of room to "look" in the photographs.

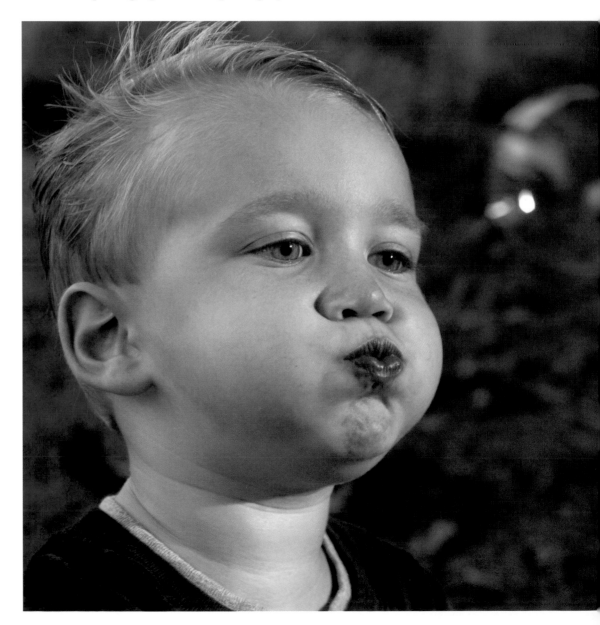

If this boy didn't have enough room to blow the bubbles, they'd look like they'd be popped by the edge of the frame. The extra room gives them safe passage.

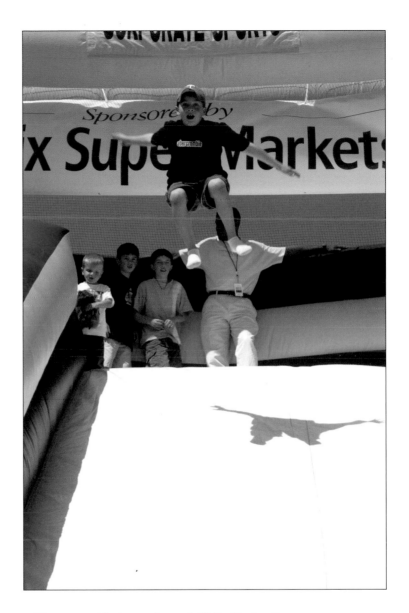

Give your subject room to . . . fall? Positioning the jumping boy at the top of the frame involves the viewer in the nauseating thrill of the plunge. Positioning him at the bottom would have suggested that he was about to land, which isn't nearly as exhilarating as the fall itself.

Both these images utilize the Rule of Thirds, placing the boy's eyes in the top third of the frame, but one shot is clearly more natural than the other. The near image seems cramped, while the far one gives the boy enough room to look.

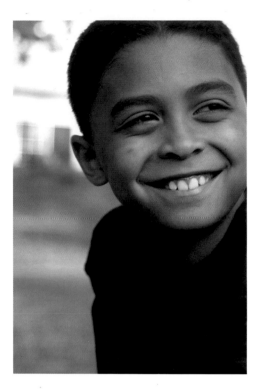
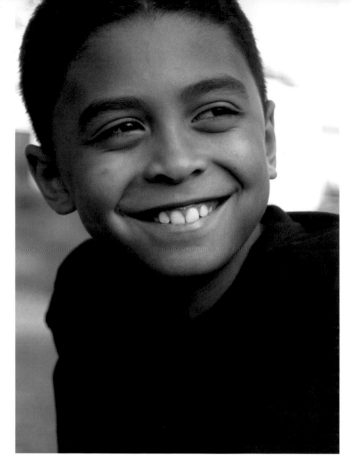

FOCUSING ON AN OFF-CENTER SUBJECT

Observing the Rule of Thirds and giving your child room to look might present a focusing challenge for your camera. Most automatic cameras are designed to focus and measure light based on the center of the frame (and a centrally placed subject). To keep an off-center subject in focus, you'll need to trick your camera into focusing on something other than the frame's center area.

Assuming your camera has a focusing-lock feature, center your subject in the frame and depress the shutter button halfway to focus and lock that focus. Without letting up on the button, move the camera to recompose the frame as desired. Then fully depress the shutter button to take the photo, and your subject is off-center yet remains in focus. Read your owner's manual to find out if your camera has a focusing-lock feature, and if so, learn how to use it for more rewarding focusing control.

It's always easier to ask forgiveness than permission! This toddler's expressive face gives her intention away, but the extra room in the picture enhances the sense of a guilty move and a parent's watchful eye.

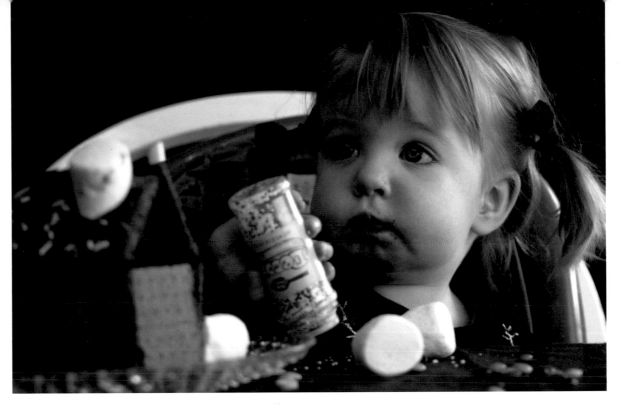

Stage actors always direct the action toward the audience in front of them, so give performers some room (above) to include the implied audience in the picture.

▸▸ Change Your Perspective

Take advantage of a child who's behaving well or is inactive for a few minutes by taking several shots, cropping differently each time. Try shooting from different angles, getting closer or even further away, and don't forget to turn your camera to try a vertical or even diagonal shot. Experimenting with your perspective stretches your imagination and can get great results that you may not have expected.

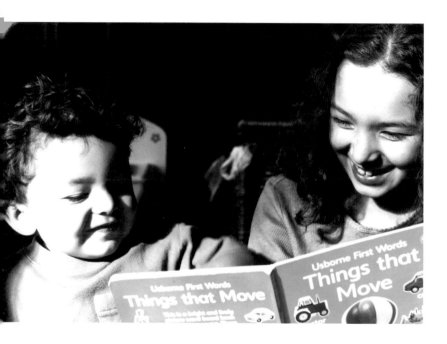

The photo above saves a warm moment between siblings that could easily stand on its own. By changing your viewpoint, however, you'll capture differing perspectives that you may like even more than the original. At the very least, you'll gain a more complete record of the experience.

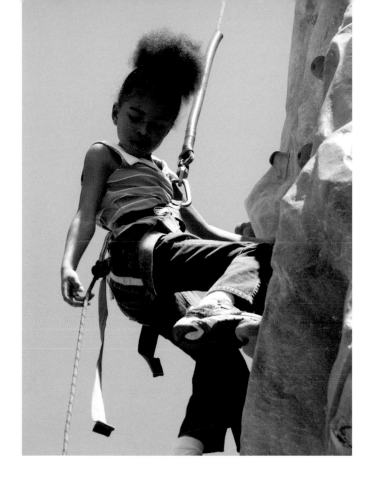

Look closely at the different stories these two pictures tell. The first one (left) is a basic shot of a girl on a climbing wall. It's not bad, but the image below tells the story of a child's desire to overcome and achieve so much more completely. Sometimes, your perspective behind the camera is the most important storytelling tool. Escape from your everyday perspective and look through the eyes of your child to find a new one.

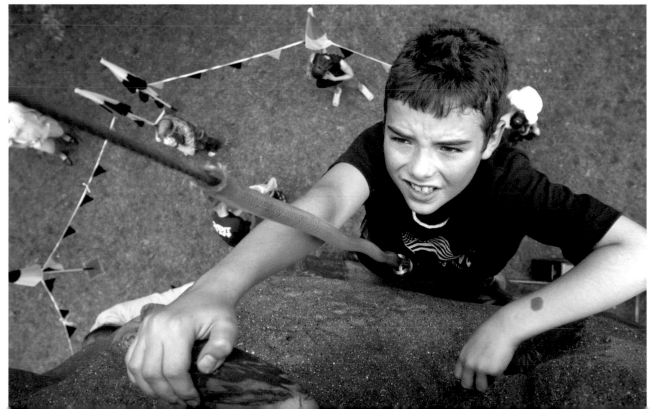

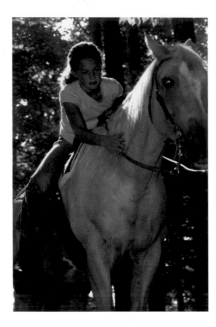

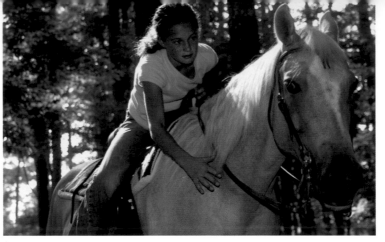

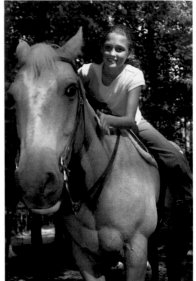

**Try shooting
from different
angles.**

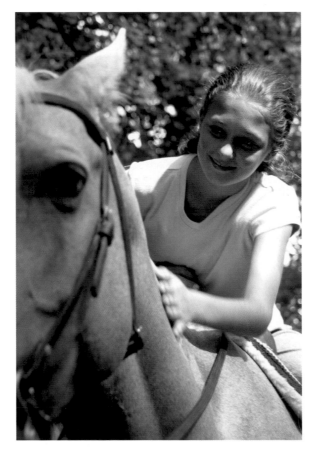

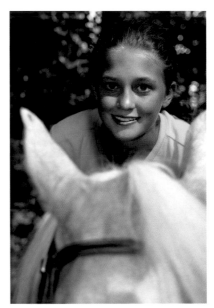

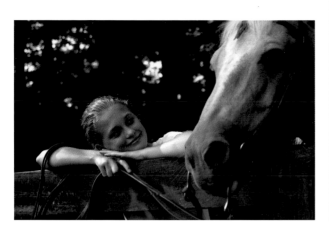

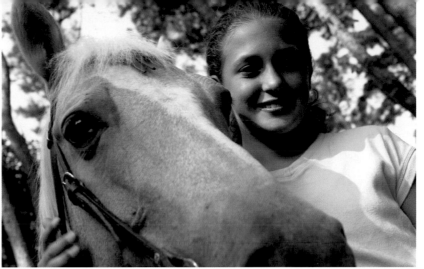

A beautiful summer afternoon and a benign horse mean taking plenty of pictures. Of course, not every one will be a keeper, and not every one of these is. But more than just one shot came out. And since I switched angles, instead of getting three or four great images from the same angle, I now have many perspectives from which to choose.

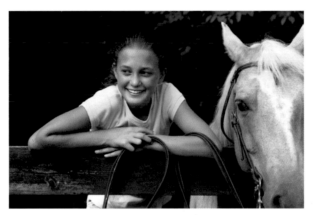

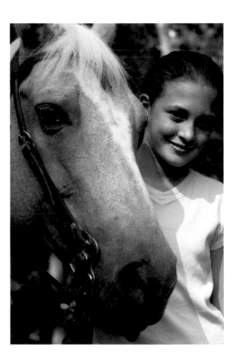

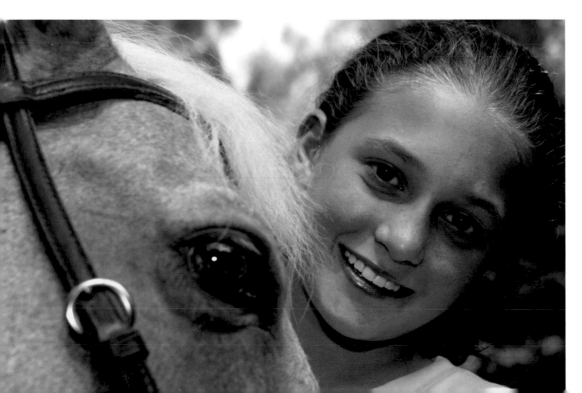

▸▸ Watch the Background

The background of a photograph comprises all the elements located behind your subject. It's easy to become so involved with your subjects that you don't pay attention to what's going on behind them. This can be a problem. How many times have you thought you've taken the perfect photo only to be surprised when it's developed? For example, the dog standing behind your son didn't bother you when you took the picture, but now your son has a tail coming out of his ear. Or, you managed to capture the perfect insightful expression from your teenage daughter, but now the poster of the grunge band behind her spoils the mood.

A little careful forethought can prevent many background mishaps. Just remember that all the elements in a photograph are potentially competing with your subject. It's your job to make those elements complement—not compete with—your subject. A clean background ensures that the attention will be focused on the subject: your child.

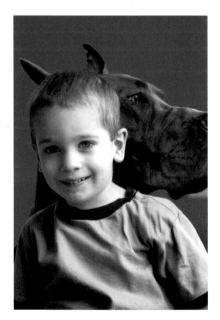

Whose ears are whose? A lucky snap snares this image of blended features between boy and dog, but it's hardly the type of photo that wins longtime affection. The picture is funny, but just too peculiar to take seriously. A pet's unpredictability requires that you keep taking pictures. Keep your child's face and your pet's face close together, and shift angles to reduce the chance that your child will end up with four ears or a tail.

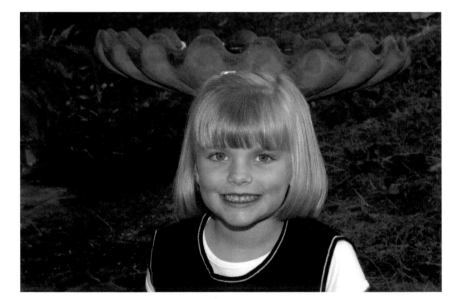

Meet the poster girl for the Order of the Moose Lodge. The Grand Poobah would be so proud, but most parents wouldn't be thrilled. Consider moving just a few feet in either direction to take the birdbath out of the frame.

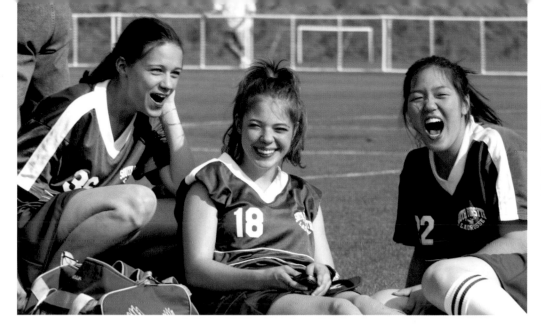

At first glance, this photo is a prize for having snagged the infectious giggles of these girls. But once the derriere in the upper left-hand corner catches your eye, it's next to impossible to see anything else. I could have avoided this unsightly inclusion by moving five feet to the left before shooting.

Cute girl, bad background. Move closer or change locations.

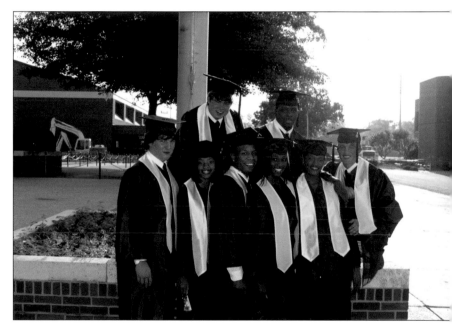

Parents get only one chance to record on film certain events in their kids' lives, such as the elation felt on graduation day. As esteemed as the graduates look, this image is weakened by the backhoe tractor in the background and the bright orange construction fence splitting both sides of the photo. Try shooting instead from a different angle that has a solid or benign background, or move in close enough to remove the distractions from the field of view altogether.

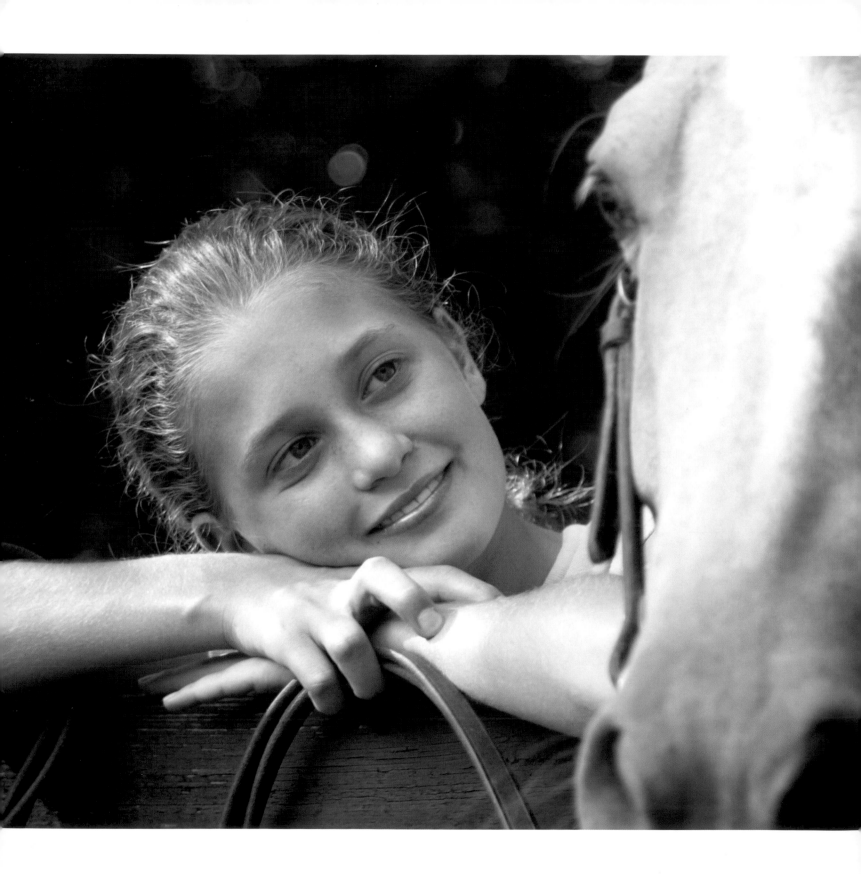

Light

The right light in a photo can truly set it apart from the average picture. Just keep in mind that *quality* of light is far more important than quantity of light. Quantity implies complete illumination, which isn't really our goal. Light is one of those areas where less is usually more. *Quality* refers to the soft, warm glow that illuminates the soul of a child. It creates a mood of intimacy. It's light that you forget to notice because you are so completely engaged with the subject. That's the good stuff, and it's also free and incredibly easy to use. Just go outside or find a window, and go to work.

▸▸The Effect of the Sun

You should be aware of how the angle of the sun can impact your subject and, therefore, your pictures. You'll want to avoid angles that put your child's eyes in shadow or that make your child squint uncomfortably. The next time you're out with your kids, make a note to look at the shadows on their faces and determine if the light is good for pictures. Pretty soon your eye will quickly recognize good light and bad.

The photos opposite act sort of like a sundial, showing sunlight's effect—from different angles—on a girl's face. The central "sun" shows what the position of the actual sun was relative to the subject, and the central arrows show the direction at which the rays of sunlight hit the subject in each example. The cameras below each image indicate where I was in relation to the subject (that is, in front of her). The sun is quite bright and harsh here, but the photos are still effective in showing the resulting shadows on a subject.

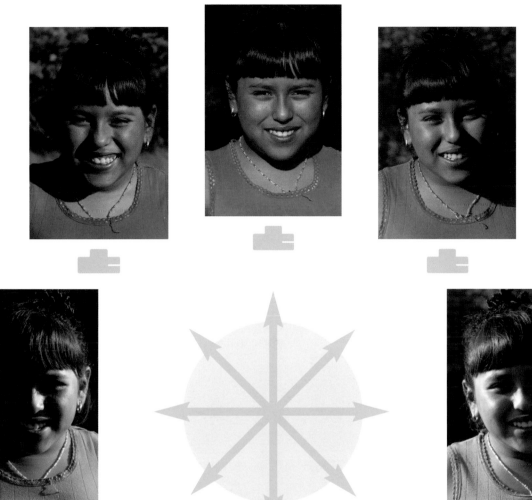

Morning and Late-Afternoon Light

Since most of us can't afford elaborate lighting equipment and wouldn't know how to use it if we could, we need to utilize the best and cheapest light available to us: sunlight. Natural sunlight is especially good for the types of candid photos parents take. It can provide some of the most beautifully pleasing hues, but is also capable of extremely harsh and unnatural effects. Sunny conditions in the early morning or late afternoon—also called the golden hours—yield the softest, most pleasing light, which is best for taking pictures.

If possible, try to avoid shooting during the midday hours. The light is quite harsh, yielding unflattering facial shadows and often causing squinting. By contrast, rainy and cloudy days present varying light tones, and offer a great chance to integrate a different mood into your photos.

Just look at the difference a few hours can make. Time of day is the only variable in these two photos. The eyes squint and are lost in shadow above, and the viewer can sense that the boy is just begging to go back inside. At right the warm light of the afternoon sun relaxes both the boy and the viewer, making for a much more pleasing photo.

Just as shooting during midday can bludgeon nice features, waiting too long for the sun to go down can cast a murky veil over them (below).

This photo shows just how wonderful soft light can be, and the proof is in the facial shadows. Look closely at their faces and notice that there isn't a definitive shadow line. The light slowly and gently graduates into shadow, and that makes for a very relaxed scene. This shot was taken on a slightly overcast afternoon, conveniently after school and after dad got home.

▸▸ Light the Eyes

I can't stress enough how important it is to focus on the eyes when taking pictures of children. They should be your primary point of interest. Once you've learned how to position the eyes in a composition, polish off the picture by lighting them. By that I mean capture the reflected light that bounces off the eyes.

A simple turn of the head provides the much-needed sunlight from a nearby window to bring out this boy's eyes. Try to locate, and take advantage of, any light sources that can brighten your child's eyes.

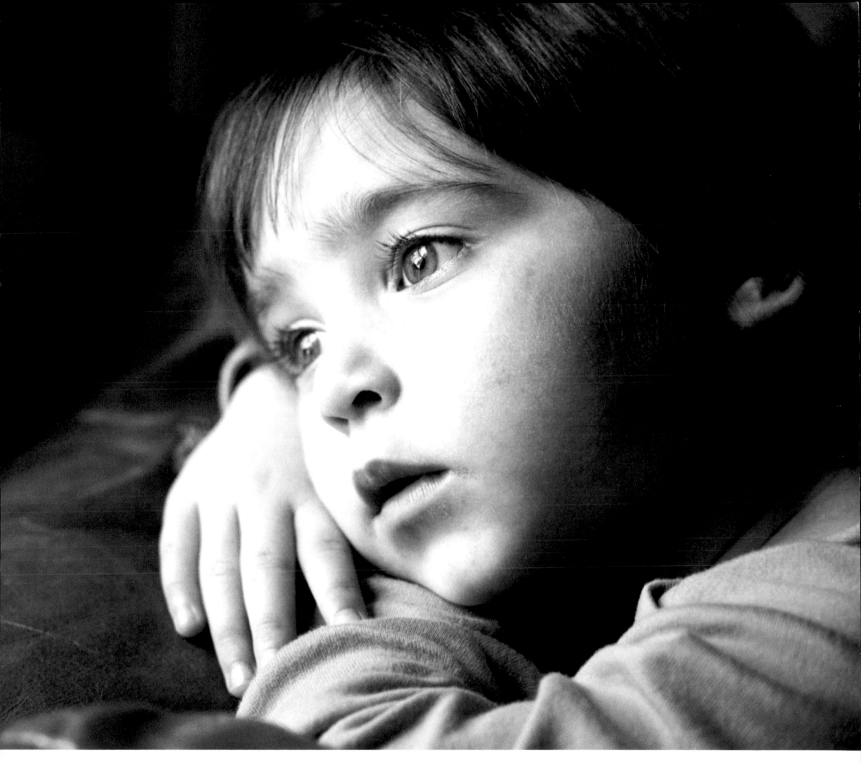

See that "catch light"? That's reflected eye light, and it adds a professional touch to intimate close-ups.

▸▸ Turn the Flash Off

Most cameras come with a built-in flash that automatically fires as a part of normal operation. It's a noble gesture, as the flash is just trying to ensure that there's enough light. But, we don't want enough light—we want better light! The flash delivers an explosion of light that burns away the intimacy of any picture. The solution is, oftentimes, to simply turn the flash off.

Here, a little girl enjoys a catnap on a rainy day. The soft light from the nearby window envelops her, creating a dreamy scene of angelic innocence. Imagine yourself coming upon this scene and tiptoeing to the cabinet to get your camera. You frame the shot, slowly depress the shutter button, and suddenly a furious burst of burning light rages toward the girl. It arrives with the subtlety of a freight train, assaults the serene scene, and very likely wakes the subject. Gone is the intimacy. Gone is that ethereal glow. The flash sears away the emotion that drew you to the photo in the first place. But when you turn the flash off, the camera adjusts to the lower level of light and balances the photo using the light that's available—leaving you with the lovely scene you remembered.

Sometimes, natural light isn't available or there just isn't enough of it, such as at night or inside a building with no windows. At that point, you're limited to what the flash can offer. However, if you have even a little natural light, find out how to turn your flash off, and just do it—rely on the existing soft, natural light to warm the mood of the picture.

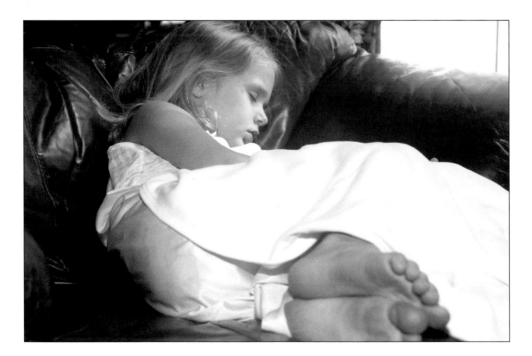

We don't want enough light— we want better light.

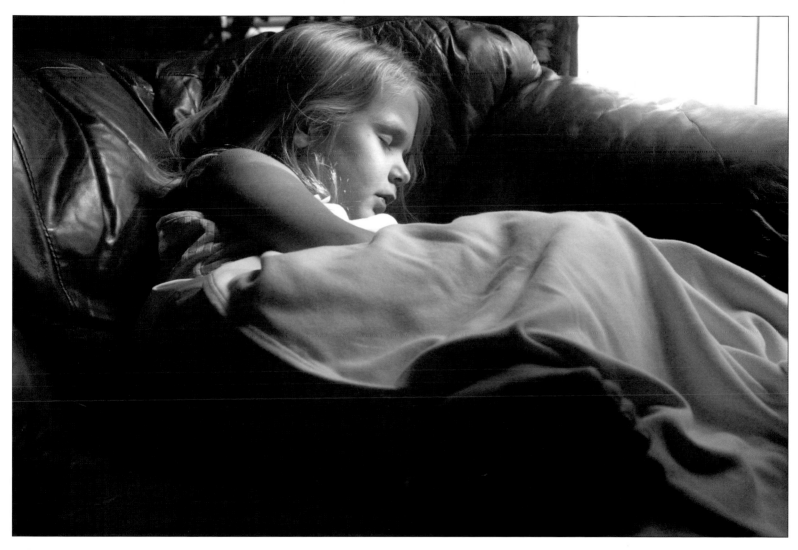

The use of only natural light (above), as opposed to flash (opposite), greatly influences this picture's impact. The lack of light on the unimportant elements, such as the girl's feet, actually strengthens the sleepy scene, leaving the viewer lolling in tranquility.

▸▸ Turn the Flash On

On page 38, I encouraged utilizing the morning or late-afternoon light for most of your photos. So what do you do when a birthday party is scheduled for high noon? Having just told you to turn your flash off, now I'm telling you to turn it back on. Strong midday sun produces harsh shadows, and a very important element gets lost in those shadows: the eyes. The brow hides the eyes in its cast shadow, and the result is a very impersonal, brash photograph. The flash can throw light back onto the eyes, making them the focus of attention again and turning less-than-ideal conditions into viable photo opportunities.

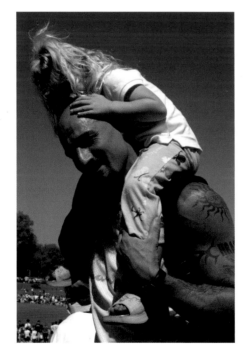

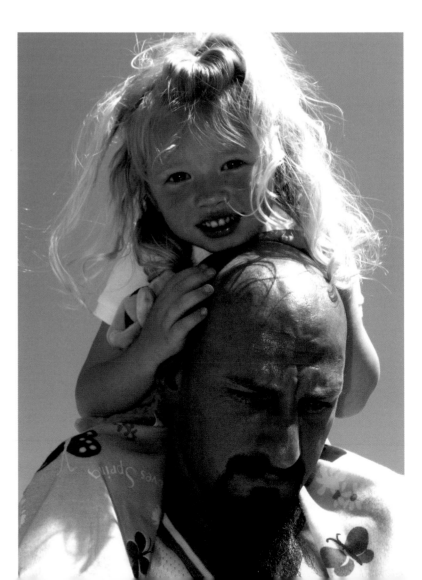

In midday light, the tattoos and sculpted physique of this man are immediately noticeable. There is what appears to be a little girl on his shoulders, but unfortunately, she is completely lost in shadow. She could be a stuffed animal for all we know. Simply moving a little closer and turning on the flash reveals the girl's innocent features, and she easily steals the viewer's attention from her father.

Harsh shadows can completely disguise a scene. In the near photo, the teen on the right is virtually featureless, and similar shadows distort the face of the girl on the left. The only difference in the far photo is that I used a flash.

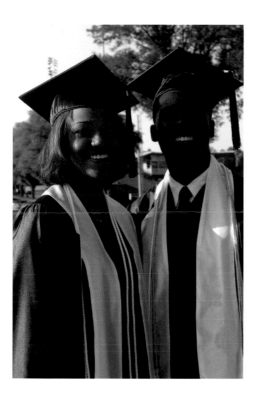

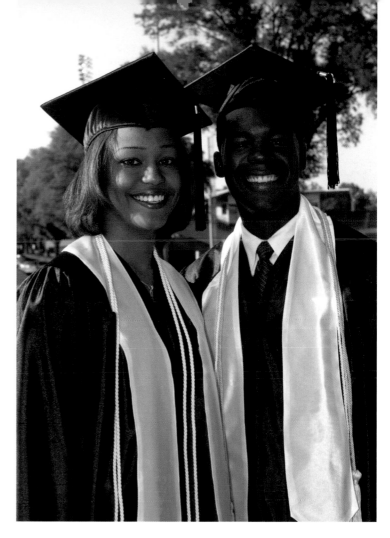

The eyes of this little girl surely would have been lost under the brim of her hat had I not used a flash. Simply by turning it on, I was able to cut through the shadows and find her sweet features again. You can tell by the bright light reflected off her father's back just how hot and intense the light was that day.

NATURAL REFLECTORS

In addition to flash, look for natural reflectors that also do a good job of reflecting light back onto your subject. White sand, a white bathtub, snow, a white tablecloth, and really any lightly colored surface can be incorporated as a natural reflector.

▸▸ Backlight

Backlight occurs when the primary light source is located somewhere behind the subject. Many people are warned to beware of backlight, because it can fool a camera into thinking there's more light on a subject than there is. The result is a picture that's brilliantly illuminated in other areas, but the person's face is cast in a deep shadow, making the features all but disappear. Personally, I love backlight and look for opportunities to use it. Backlight can produce an exquisitely intimate feel and appears to set hair ablaze. And since I know that the pitfall is a shadowed face, I simply turn on my flash to light the face.

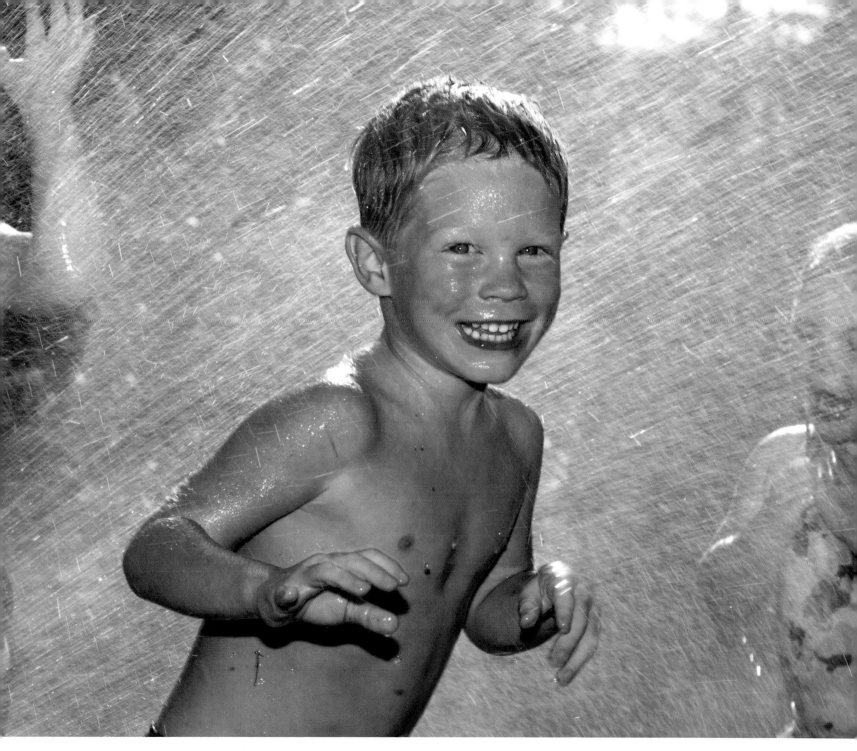

Watery scenes respond wonderfully to backlight, because water droplets and spray appear as sparks. Without the flash, however, the subjects become unrecognizable silhouettes. Turn the flash on to record the water-logged scene as your eyes remember it. Consider using backlight the next time your child wants to help you wash the car.

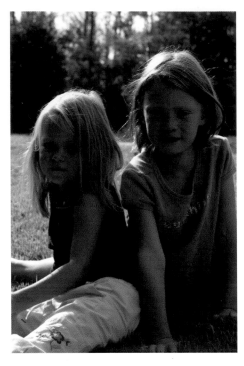
Without Flash.

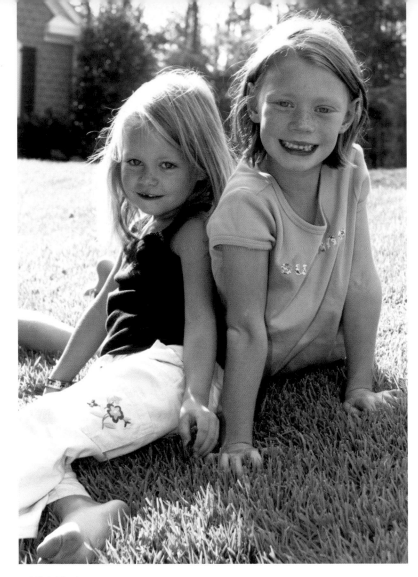
With Flash.

This is backlight at its best, producing a soft appealing light. Notice that the beautiful highlights in the girls' hair are the same in all the shots, but the absence of flash fill light (in the images taken without flash) leaves you straining to see the details in the faces.

Without Flash.

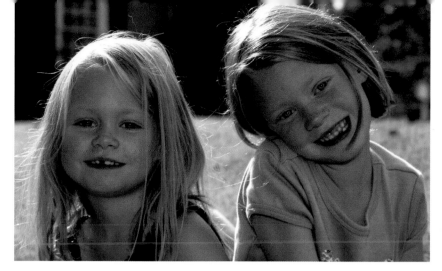

With Flash.

Backlight can produce an exquisitely intimate feel and set hair ablaze.

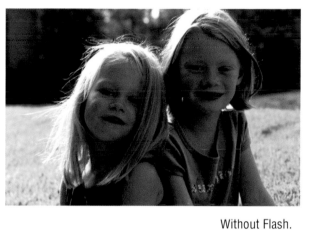

With Flash.

Without Flash.

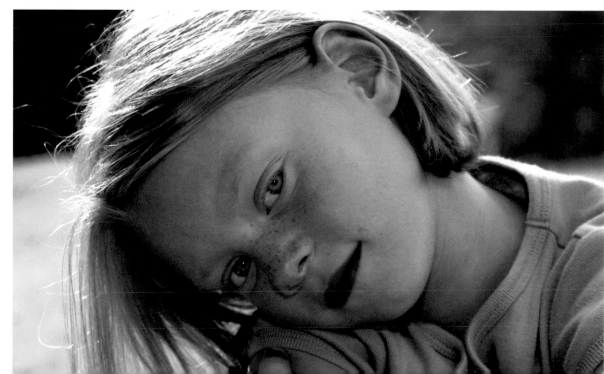

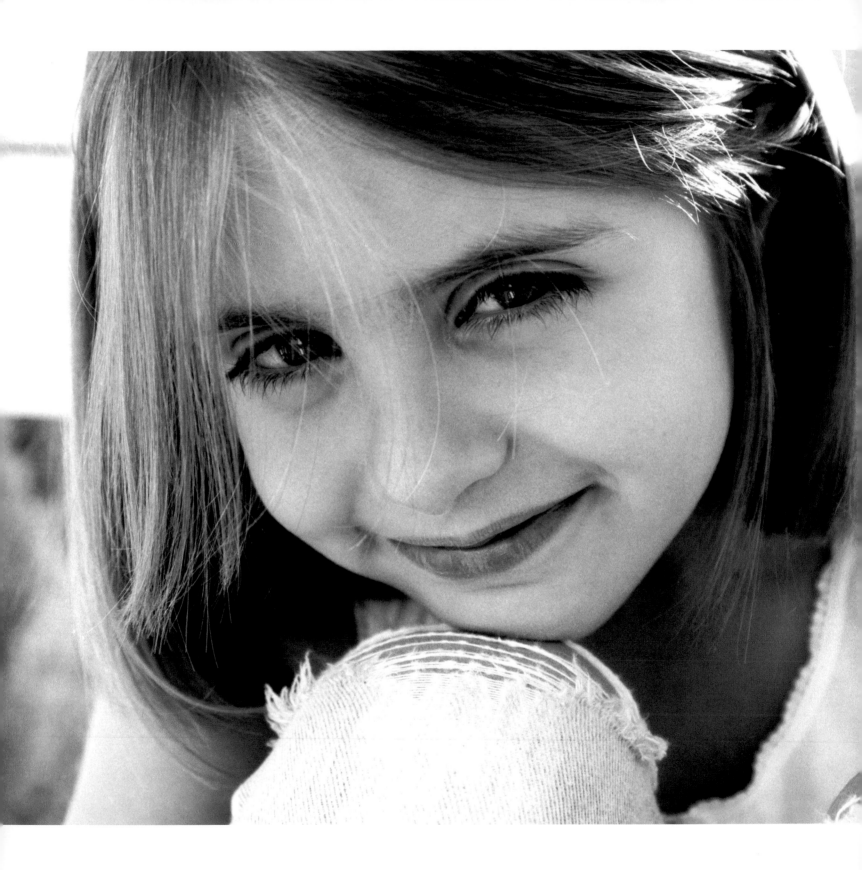

Techniques

Now that you've learned the basics of how to use your eyes, I'll introduce some new ideas to further refine the quality of your photos. Some scenes call for using a few of these techniques at once, while others need just one or two. With every photo, practice at least one technique until you can rely on it. Practice these techniques (plus the basics of composition and lighting) enough so that you aren't deliberately using them in your pictures, but rather so that they reveal themselves effortlessly as you frame each photo.

Part of this involves looking for ways to connect with your kids. If you're just approaching them with a camera, you're no different than a stranger at the local photo studio. Spend time relaxing and playing with your kids—and watch as the inhibitions melt away to reveal some truly golden moments.

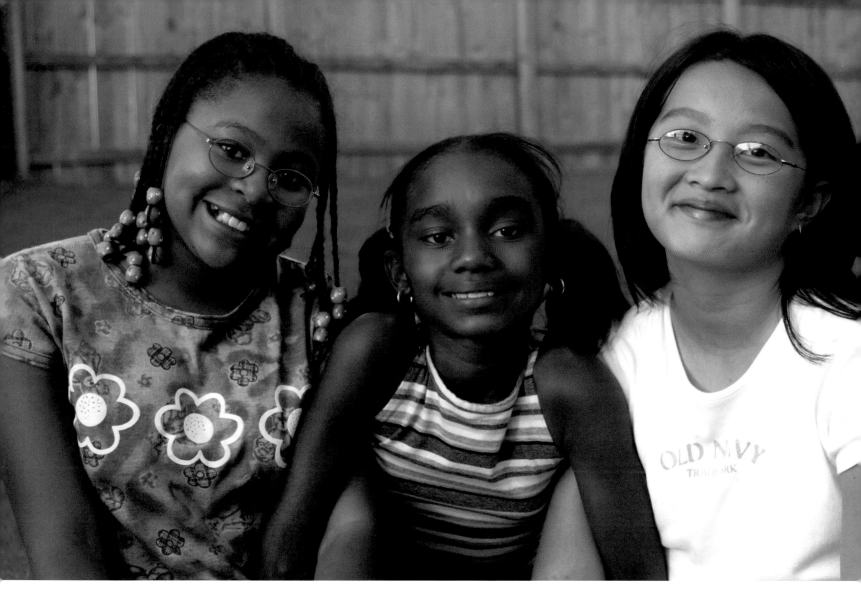

▸▸ Keep Shooting

Too often, parents take only one or two shots of their kids, and this doesn't allow for variables like closed eyes, turned heads, or half-smiles. Furthermore, for every additional child in the photograph, the chances for facial quirks and distractions increase exponentially. When you can, take at least two shots of a scene—

preferably four to five or more—and don't be afraid to keep on clicking if your kids are behaving especially well. The extra snaps will give you variety in expression, perspective, pose, and composition.

Photographers from major magazines come back from assignment having shot hundreds or even

thousands of photos, all in an effort to capture a single beautiful image. They may have taken ten or more rolls of the same subject, with different approaches to lighting and composition. Most of the images are left on the editing room floor, but the "keeper" that's printed makes us wonder how they did it. But, here's the disclaimer: Shooting hundreds of images is no guarantee of getting a keeper. Still, balancing that with a little technique and some experience certainly increases your chances. Just use common sense, and don't be afraid to take a few extra snaps. Remember, film is far cheaper than opportunity. The goal is not to have a roll full of great shots, but to have a roll with at least one priceless shot and several very good ones.

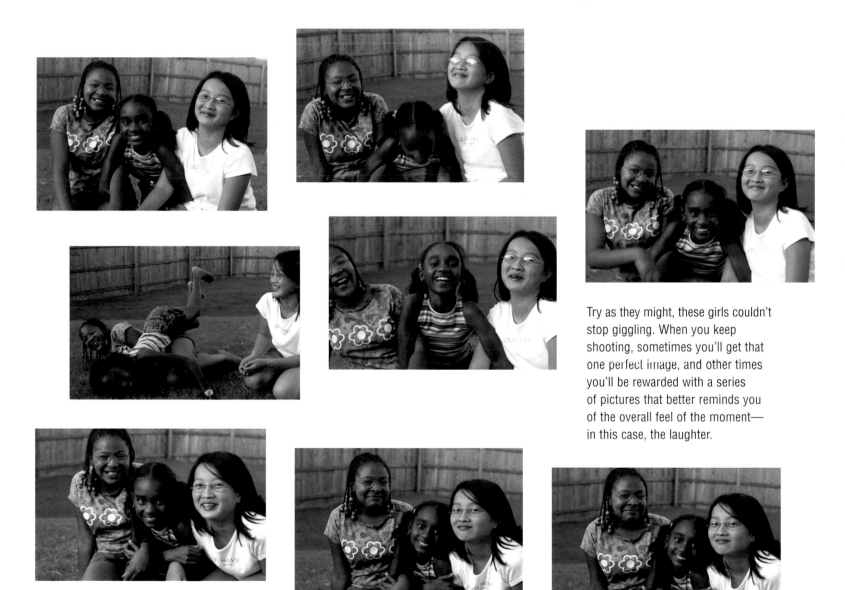

Try as they might, these girls couldn't stop giggling. When you keep shooting, sometimes you'll get that one perfect image, and other times you'll be rewarded with a series of pictures that better reminds you of the overall feel of the moment— in this case, the laughter.

Taking pictures of a toddler at a birthday party can be a difficult task. With all the sugar and social stimulation, a child's manner can resemble that of a bobble-head doll. Be patient, and when you see your child's eyes, fire off several frames to make sure you get the shot.

In most cases, you keep shooting in order to guarantee getting one great shot. Sometimes, however, you'll really score and get several winners. The subtle differences in expression may not be noticed by friends, but parents will recognize and embrace each variation. A series like this looks great matted together and framed.

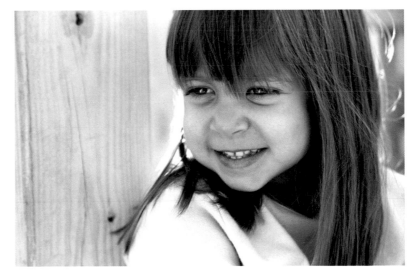

▸▸ Shoot at Eye Level

Many parents relate to their children on an adult level. They try to make them understand adult reason, adult discipline, and adult behavior. As their children grow, however, most parents do learn to meet their kids where they are so that their kids can understand mature concepts a little easier.

At a very basic level, the same is true when you photograph your kids. You need to get down on their level—into the blades of grass, bruising your knees on rocky soil, and scuffing your elbows on the pavement.

In photos taken while the parent was looking down on the child, there is a disconnect between the viewer and the subject that cannot be overcome, and the images are not visually engaging. Compare with photos taken by parents who were at their child's eye level; there's an immediate connection with the child in those photos. There's a sense of participation with the child—as if you are there with them, feeling what they feel, licking their ice cream. That's the kind of photograph worth looking at again and again.

The image at right shows a typical approach to taking pictures of young children: shooting down on them. But look at how mom's change in position drastically affects the quality of the picture she gets (opposite page). At eye level even the trucks seem more realistic, and the viewer experiences the moment of play more intensely.

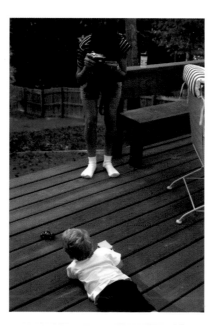

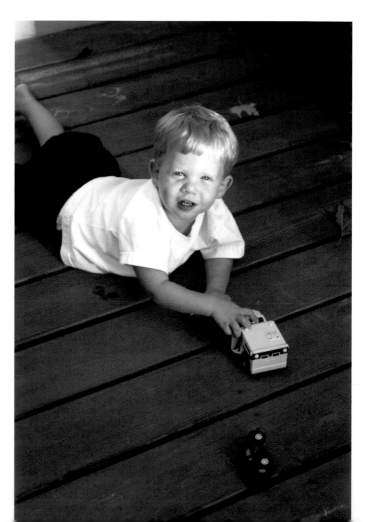

TODDLER TIP

Having toddlers requires that you be willing to get down on their level. While you're down there, you might as well hang out with them for a few minutes. For one thing, it can take most of us adults a few minutes to get back up, so why fight it? For another, your kids will appreciate you playing with them on their level. Ever thought about how uncomfortable it is for them to always be looking up?

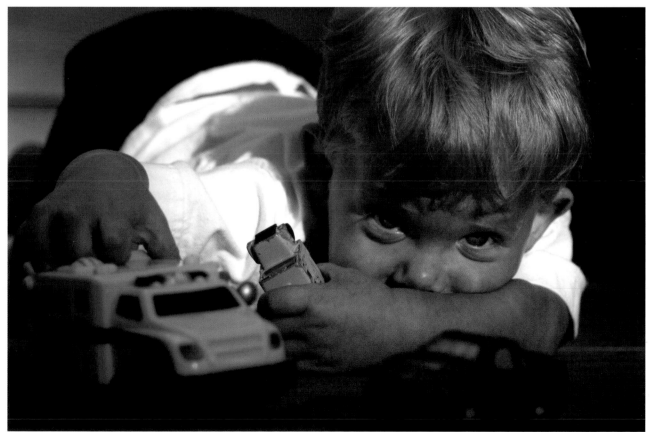

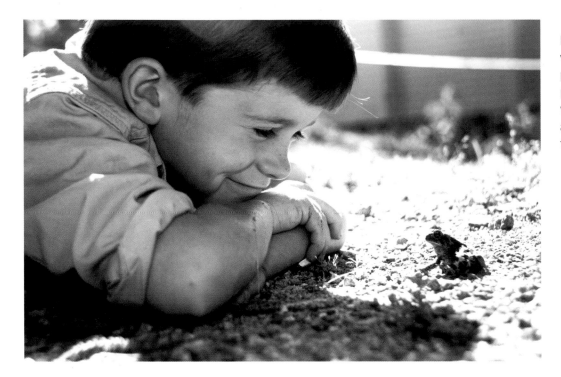

Believe it or not, this picture was actually very easy to take, but it wouldn't have been possible from a comfortable standing position. I simply lay down on the ground with the camera as close to the ground as I could get, then I fired off a few frames. Was it worth it? You bet.

The difference between these two pictures is strong, with the far one clearly the warm winner. You're just waiting for her to break that water stream. There's no such excitement in the near photo, because the perspective removes the viewer from the scene and out of umbrella range.

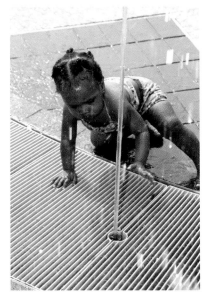

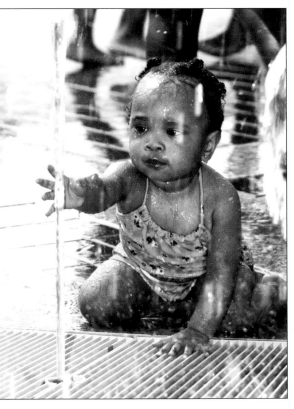

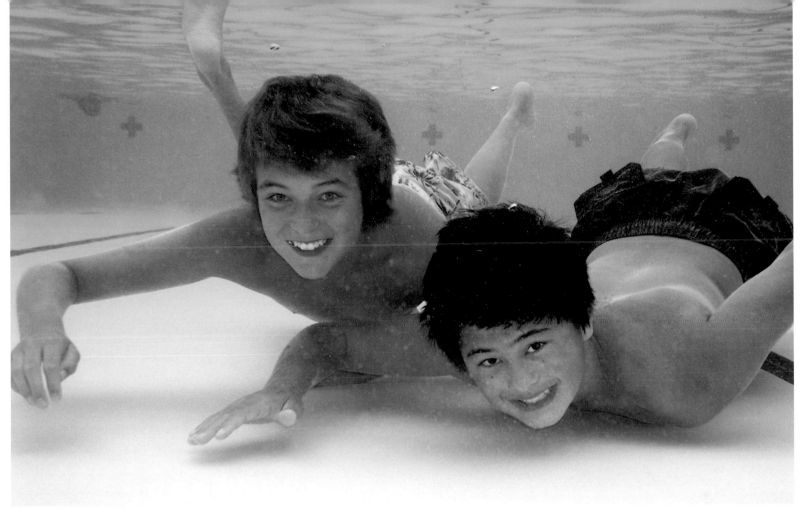

You may get a good tan from the comfort of a poolside lounge chair, but you won't get a very good picture of your kids in the pool. To truly capture your children's experiences, you must be prepared to dive into their world as a participant. Not only will you win a keeper for your photo album, you'll win the hearts of your kids.

When you photograph your kids, you must get down on their level.

SUMMERTIME TIP

Kids love playing in the water, be it a pool or just a yard sprinkler. Buy a cheap disposable waterproof camera and keep it in your pool bag. You won't damage your regular camera, and you'll be even better prepared to get good snaps of your kids at play.

▶▶ Focus on the Eyes

When taking a close-up photo of a child, there's really only one thing to remember: Focus on the eyes. While a person's eyes may or may not be the window to the soul, there is no doubt that the eyes are the anchor of any photograph. All the other features—the smile, the hair, the hands—work together to complement what the eyes are "saying."

It's interesting that if the eyes of a person are in focus in an image, then the entire photo looks crisp even if the other elements are not. If the eyes are out of focus, then everything looks blurry. It's especially important to ensure that the eyes are in focus when you take a close-up shot of someone's face, and utilizing the focus-lock feature on your camera (see page 26) will help you get that crispness.

Wanna take a guess what the subject of this picture is? The girl fills up the entire frame, so it must be her, right? Not exactly. Forget for a moment that this girl is anything more than a collection of ingredients in a picture: arm, knees, falling strands of hair. These are all important features, but which is most important? Remember that you're trying to focus on the eyes, especially in a close-up shot, so consider them your subject and apply the Rule of Thirds to balance the image.

A NOTE ABOUT PACIFIERS

Some toddlers rely heavily on pacifiers and rarely remove them from their mouths. Since the pacifier is so frequently present, many parents forget it's there when taking pictures of their kids. A pacifier rarely adds charm to a photo, and because it's in the child's mouth, it acts as a magnet, pulling your attention away from the eyes. It also effectively hides a smile. When possible, try to remove the pacifier before taking photos of your child.

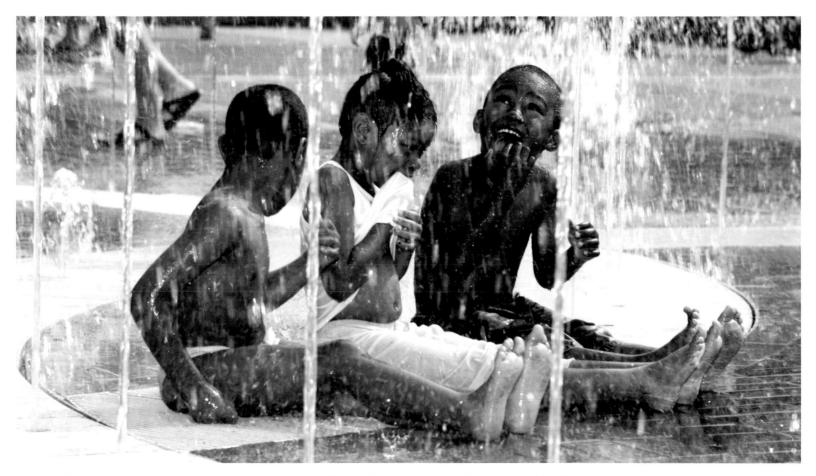

Look at this photo for one second, then look away. Look at it again for one second, and look away again. Repeat five times. How many times did your eyes go to the little boy on the far right? Like water searches for a drain, your eyes search for a way to plug into a picture, and his eyes are it. No matter how hard you try, you just can't connect with the other two kids, and it's largely because you can't see their eyes. As you look at your child through your viewfinder, wait a few seconds if necessary until the eyes are clearly in focus.

The eyes are the anchor of any photograph.

The emotional difference between these two photographs illustrates just how impactful engaging eyes are to a picture. All the other elements are the same, but the loss of the girl's eyes above is so disappointing that you find yourself nervously looking for the reassuring connection that the eyes bring (right).

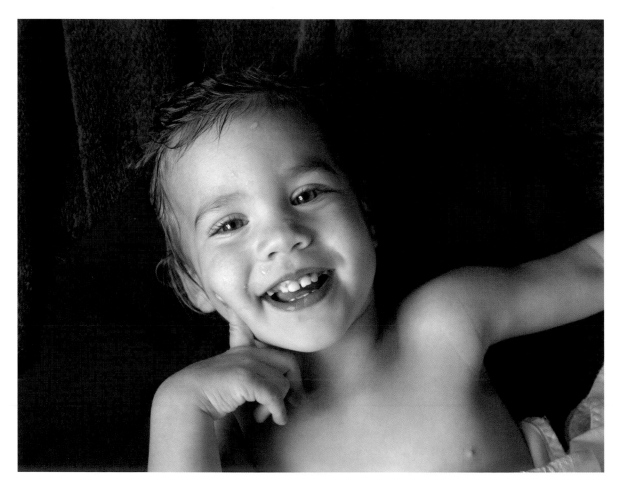

Face painting is a great excuse to get really close to your child. But even though the action is happening on the girl's cheek, her eyes are still the subject of the picture. Don't risk losing the eyes in favor of something less meaningful.

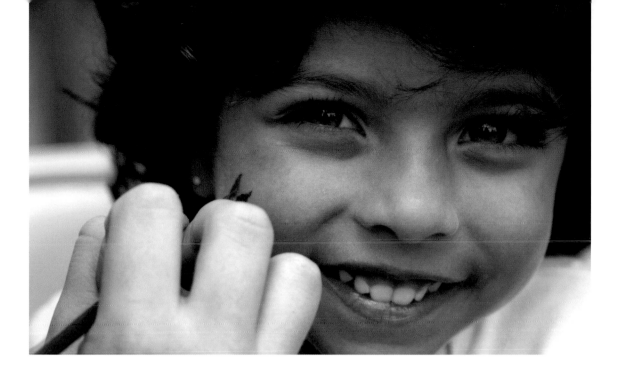

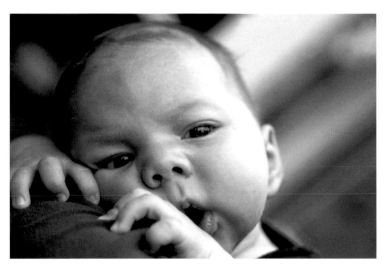

The eyes of this three-day-old infant are the clear focal point of this picture. He's resting on mom's shoulder, but the closeness of the shot discards all the unnecessary and distracting elements; the eyes are left prominent, and the clenched, grasping fingers offer balance and visual interest. Note that some of his fingers and his ear are out of focus, yet the overall picture still seems crisp. That's because the eyes are in focus. The success of this simple shot also disproves the myth that newborns and infants are both uninteresting photographic subjects and difficult to shoot.

CROPPING

Don't be afraid to cut off part of the head or hair when taking an extreme close-up. As long as the eyes of your subject are in focus and are well framed in the image, you won't even notice.

▸▸ Find a Frame Within the Photo

Look for natural ways to frame your child within a photograph. Just as a picture frame draws your attention to the photo within its borders, a frame within the photo itself will further highlight the subject of the photo. Doorways, windows, fences, old tires, and even blankets and dollhouses are potential frames. Practice looking through the viewfinder and finding alternative frames.

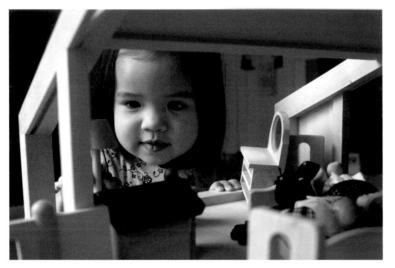

The hard thing about taking pictures of kids playing with their toys is that their attention is on the toy and not on you, making it hard to find their eyes. Look for ways to put yourself in their line of sight, as in this photo. The dollhouse frames her beautifully and allows you access to her imagination.

This little boy is practicing "cool," grooving to the right tunes in a slammin' minivan. This is such an everyday occurrence that it could easily be overlooked as a chance for a great picture. The typical perspective would be of him just sitting in the front seat having fun. But look at what a difference catching his reflection in the door mirror makes. This frame within the photo focuses your attention directly on him, all while catching him unaware for a great candid picture.

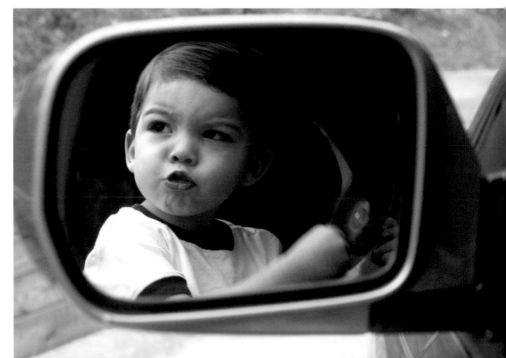

Frames are everywhere; you just have to know how to recognize them. A simple day at the park makes for a winning shot here. Be ready to get off the park bench and play in your child's world for the best perspectives.

The preserving quality of black and white suggests that both these images were taken last week, and hides the passage of time so well that you'd never know this image is over ten years old. A decade makes quite a difference in our kids, but time can't touch these pictures. Plus, they serve as a time machine, instantly transporting us parents back to earlier years, if only for a brief moment. Framing this image side by side with the one opposite would provide a nice balance of family history.

▸▸ Why Try Black and White?

I can't think of any photographs that we hope will endure over time more than those of our children. Black-and-white photography provides a timeless quality that color can't match. It de-emphasizes clothing trends, hairstyles, makeup, cars, and all the other things that tend to date pictures. It filters out the distracting elements, leaving just the raw emotion of our kids. The photos are both dramatic and warm. Additionally, monochromatic images taken over a period of years blend together beautifully, as if they were taken at the same time.

I love black and white. It just seems to capture a child's personality more purely than color. In some cases, I've found that black-and-white film is actually easier to use than color. Fluorescent and tungsten (the standard bulb) lighting can affect a color film's "temperature," leaving it with either a cool green or warm orange cast. There are no such limitations with black and white. It can also be more forgiving in certain lighting situations, so there's sometimes less of a need to be exact in measuring light.

I'm not suggesting that you use black and white exclusively, or even most of the time. But I do recommend that you try it at least once, and then incorporate black and white regularly in a healthy balance with color.

LET YOUR SUBJECT RELAX

Let your subjects adopt poses that are comfortable for them. With his dark introspective eyes, this boy is a great example of someone who isn't always comfortable sporting a grin. His true personality shines through when he's allowed to relax, and the resulting picture is a truer and more flattering depiction of him.

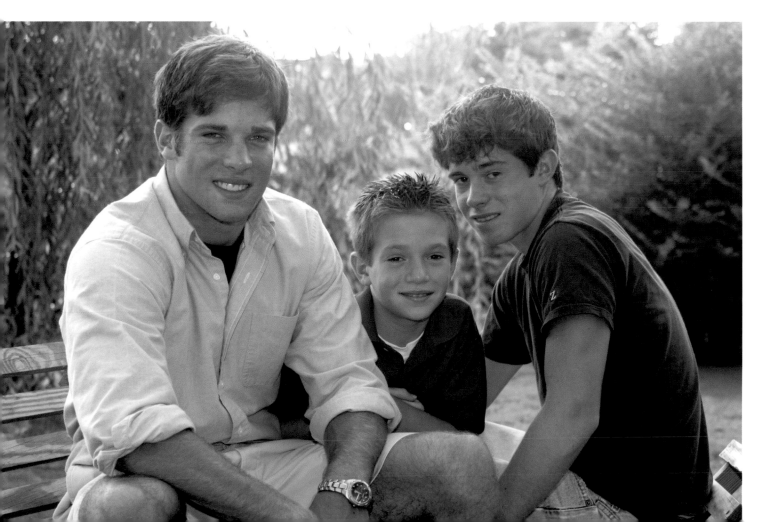

If you're waiting for your child to pose perfectly, you may be waiting a while. The upside-down orientation of this little boy is no less charming, so go ahead and take a few snaps while your kids ham it up. Black-and-white film is especially good for skin tones, so look for opportunities to use it on days your kids wear short sleeves or no shirts at all.

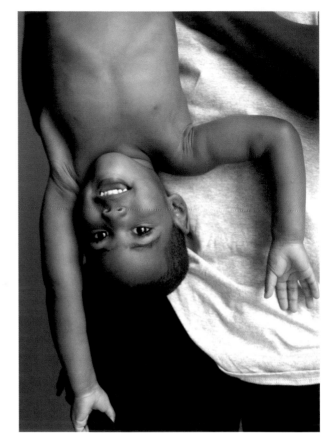

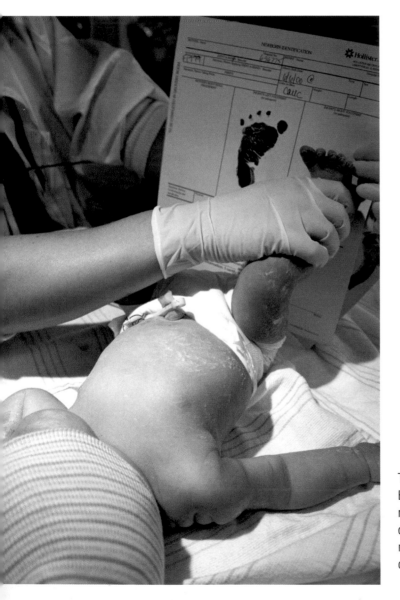

Black and white provides a timeless quality that color can't match.

The birth of a child is one of the most memorable moments of a parent's life. But the adrenaline and chaos during labor and delivery usually muddles our memory of it. Keep your camera handy and take lots of pictures so that you don't forget the rush of events. In this picture, black and white preserves the moment so dramatically and completely that a mental journey back to the delivery room is effortless.

ARCHIVAL AND PROCESSING ISSUES

From an archival perspective, black-and-white negatives and prints tend to hold up better over time. Unfortunately, color film and prints are more subject to deterioration, and changes in color processing chemicals and techniques can create inconsistencies with color prints over time. The pricing for film processing and printing is about the same for color and black and white. Some labs may need more time to process black and white, but the wait is certainly worthwhile for a photograph that will last a lifetime.

This boy's large, hopeful eyes are the focus of this image thanks to the film. Black-and-white film removes the color interference, ensuring that nothing gets in the way of raw emotion.

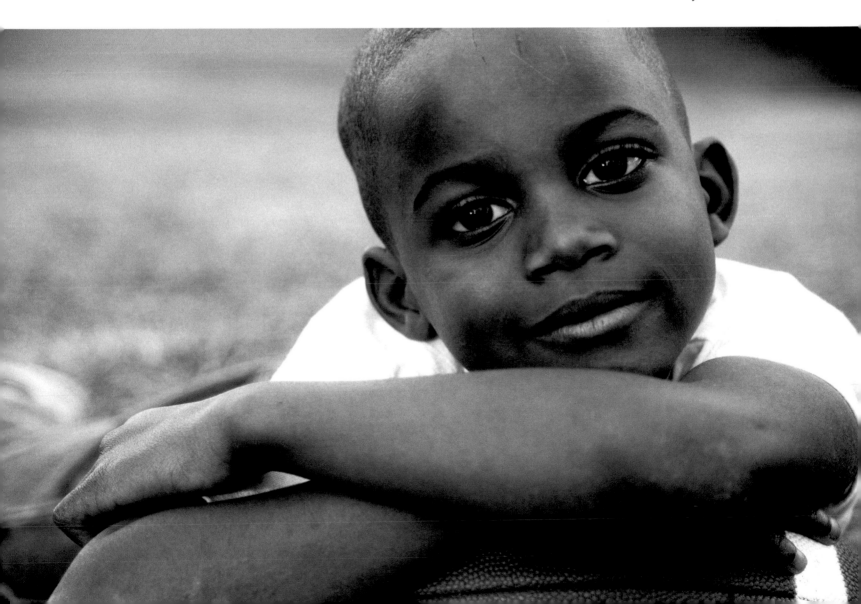

▸▸ Photographing Infants

So you have a new baby? You have my congratulations, and my condolences for the lost sleep. This is such a fun time, but as any new parent will attest, babies change so fast. Thank goodness you have your camera to record their evolving features, expressions, and personalities, because before you know it, your babies will be stepping on that bus for their first day of school.

Above all, take pictures often. Just have your camera ready by the refrigerator, the baby bed, or in the diaper bag. Watch for the cooing, the gnawing of fingers, the gentle sleeping, and even the mad hungry crying. They're all worth capturing.

In many ways, babies are easier to photograph than other kids. Think about it; for the first few months of their lives they are completely immobile. They aren't going anywhere. You can roll the crib near the window or prop your baby up on dad's shoulder and just snap away. Remember to stay extra close, position yourself at eye level, and look for the eyes. You'll be glad you did.

Bright eyes define the charm of this baby. Notice that I'm at his eye level, not dad's, and that I'm as close as I can get. The colorful cap nicely frames his face, further drawing out his eyes.

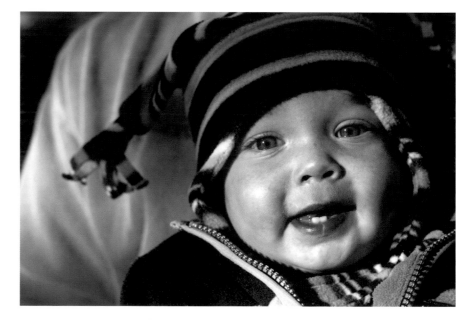

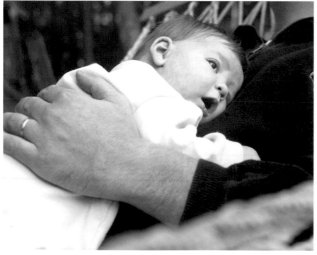

Notice this father's wedding band. To me, images that include a man's wedding ring make much warmer family pictures. It's a reassuring element that is often overlooked, so try incorporating it subtly in your photos.

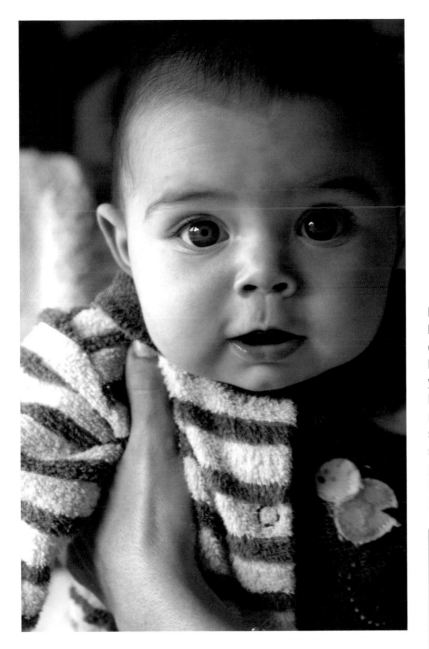

Having trouble keeping your baby's attention on you? Try tinkling keys just above or behind your camera.

Babies' eyes are disproportionately large in comparison to the rest of their features. Look for them to be the focus of your pictures and you won't be disappointed. Mom's hands and the crib bars are reassuring elements, and they show that you don't need a pristine studio-type setting to get great pictures. Additionally, following the Rule of Thirds makes for a nicely balanced image.

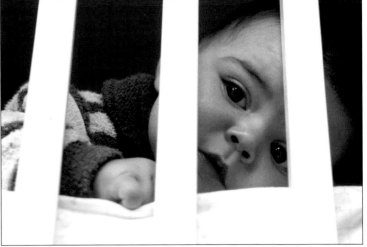

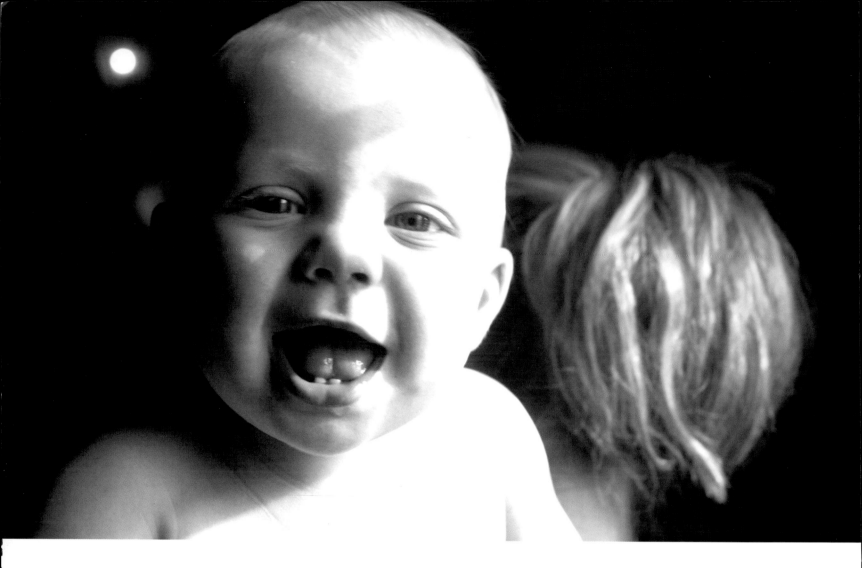

Sometimes babies can be infatuated with the lights and sounds a camera makes. Take advantage of their curiosity by taking a few extra snaps.

Also notice how the soft window light (this page) allows for a more intimate feel than the harsh light that comes from a flash (opposite). Keep in mind, too, that when using flash indoors, you run the risk of your children having the dreaded red-eye. Better to use natural light.

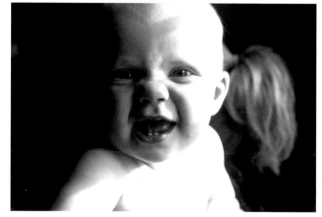

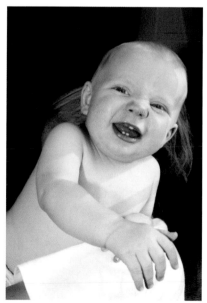

Babies change so fast. . . . Have your camera ready.

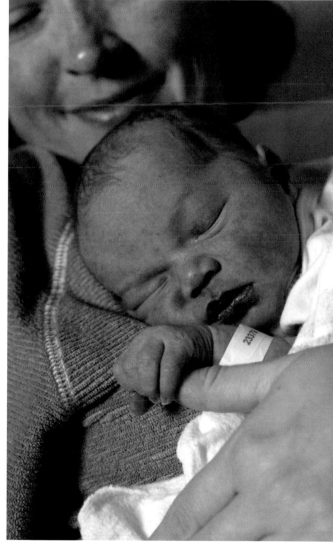

It's understandable why newborns get lots of photographic attention, and they're completely deserving of it. Decide early to stay close, so as to preserve the delicate mood. Natural window light keeps the scene soft and private, allowing the viewer to enjoy the baby's introduction to her mom.

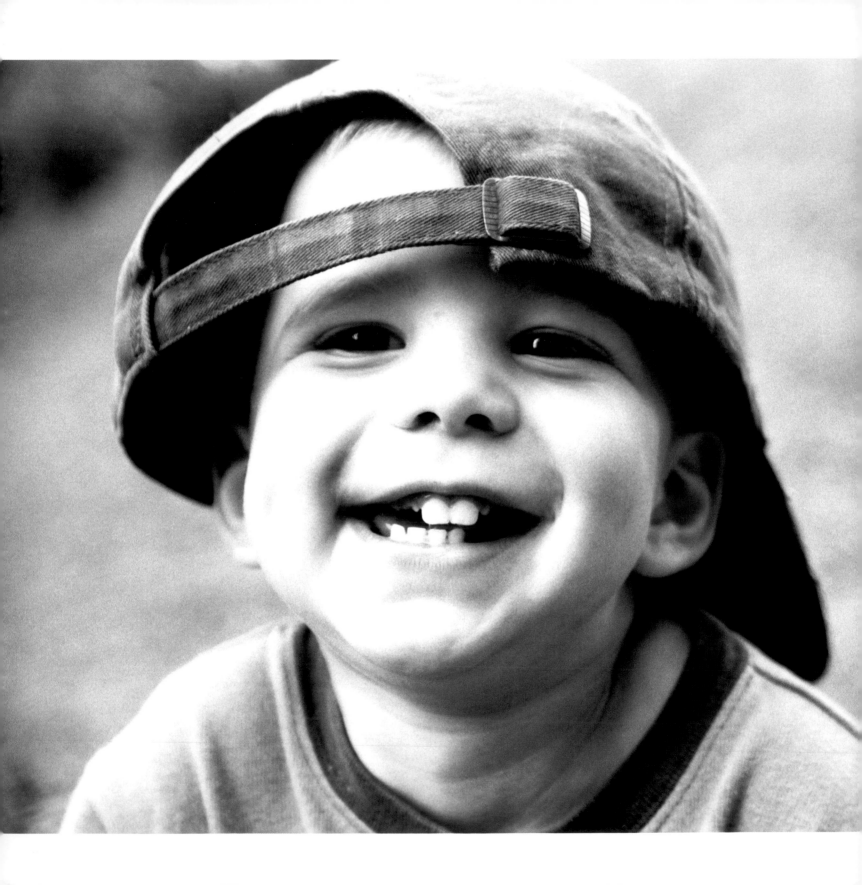

Setting the Stage

Many photo opportunities aren't planned and just happen as a result of your child doing something interesting. There are times, however, when you want to spend a few minutes and really try to plan for a few great shots, like at holidays, birthdays, sporting events, or even just family picture time. A little forethought on your part can help simplify a photo and prevent irritating distractions. The tips in this chapter can help you maintain a natural-looking scene and keep a planned shot from looking planned.

▸▸Choosing Clothes

Start by choosing a conservative clothing style. Trendy clothes are great for keeping up with friends at school, but they become less interesting in photos when the next fad replaces them. You're trying to capture your kids as they are, but also to create a photograph that lasts through all the style changes and has a permanent place in your home.

When photographing in color, choose clothing in bright, solid colors. Plaids, stripes, and polka dots will compete for attention. Also, be mindful of logos and words on shirts; they tend to date the photo and further distract from your kids. Leave clothes decorated with beads, buttons, and ribbons in the closet.

Black and white requires a little adjustment in thinking. People think in color, but black and white records in shades of gray. Dark blue, red, and green will all come across as charcoal or even black. Light pink, yellow, and blue will all be seen as varying

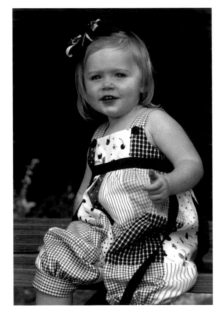

It's just not possible to find a louder, gaudier jumpsuit than the one in the picture above. The solid pink dress and simple bow (right) allow the viewer to better enjoy the demure nature of the little girl.

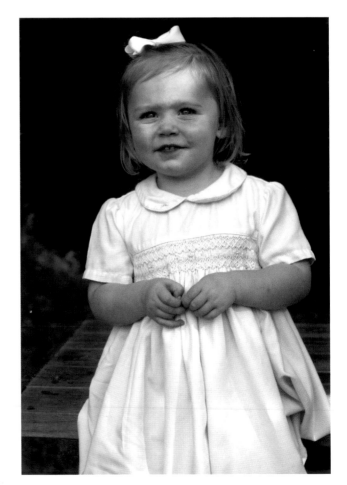

shades of white or light grays. So, instead of thinking in color, think in terms of contrast and texture. I've had great success with a simple white T-shirt and basic pants or shorts. Denim, sweaters, cotton, and fleece are great in that they all offer different textures that you can almost feel when looking at the photograph.

Regardless of which type of film you use, dress your kids comfortably—even in their favorite play clothes—so that they'll be relaxed. Trust me, a nicely pressed shirt guarantees a stiff pose. Our best memories of our kids are not the rare moments when they dress like a congressman, but rather when they have just climbed out of mud puddles.

NO SHOES

Try taking snaps of your kids without shoes on. There's an extra measure of innocence in a photo of a barefoot child.

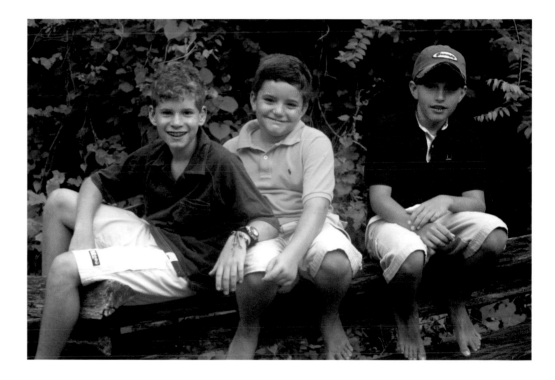

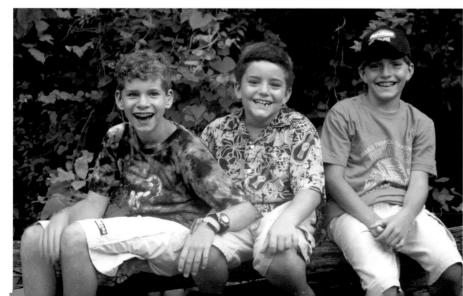

These two photos are almost identical except for the shirts. Notice how much more chaotic the bottom photo is by comparison.

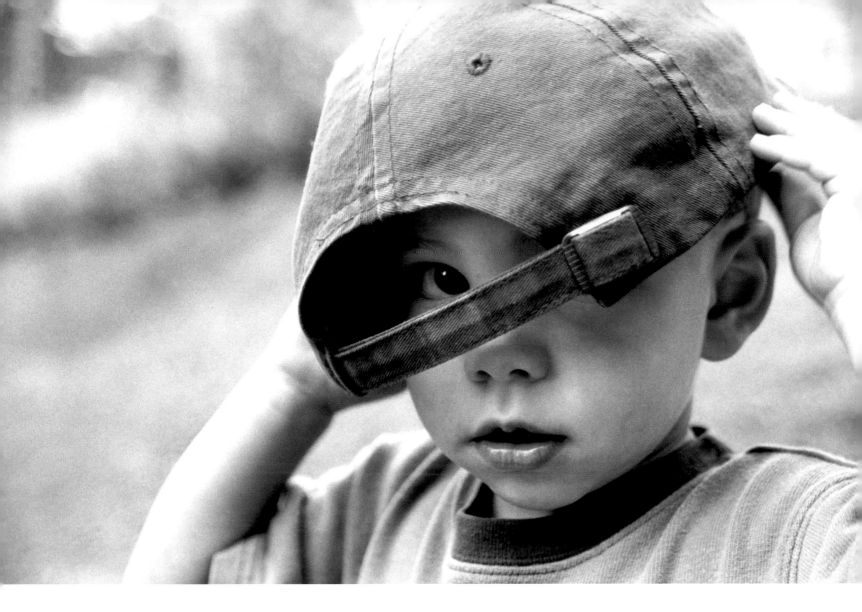

▸▸ Accessories

Accessories can be great additions to any photo—as long as they remain just accessories. Many parents overload a scene with cute props and don't realize that they've replaced their kids as the prominent subject. Accessories should enhance an existing mood or scene, not create one. Unless you're actually on a farm, for example, avoid the pitchfork and bales of hay—they more resemble an unrealistic studio setup. A good rule of thumb is to maximize your child and minimize the distractions.

Keys, a ball, non-sticky candy, or a favorite toy can all be helpful for a young child needing security in a planned photo; careful framing can keep the prop from being a distraction. Other accessory ideas include ice cream, hats, pets, balloons, sports equipment, water, flowers, sunglasses, scarves, musical instruments, and stuffed animals.

Sunglasses can be a good prop, too–just not actually on the face. The problem with actually wearing sunglasses is that they hide the eyes, and I've already emphasized how important the eyes are to a photograph. Instead, have kids prop them up on top of their head, kind of like adults do. Or, try putting them on your kid's face but letting them slide down the bridge of the nose so that the eyes are just visible. Now, the sunglasses are a complementary prop instead of a camouflaging one.

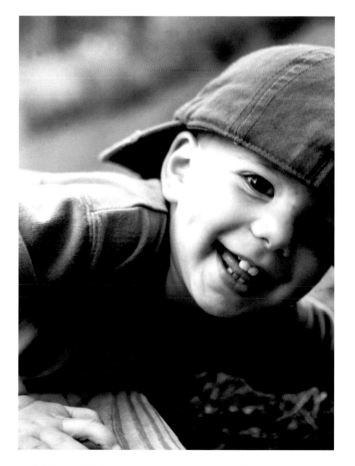

A hat can be a great accessory that doesn't distract from your child's character. For toddlers especially, try letting them wear one of dad's hats. The novelty of it entertains them, and the too-large look enhances the childlike qualities of the photo.

▸▸ Group Your Kids Close Together

Most parents would rather have a root canal than try to coordinate multiple kids for a picture. If you're trying to photograph a group, you'll definitely need extra film or memory cards. The chances for blinking eyes and awkward smiles grow exponentially with every child you add, so resign yourself to taking several exposures. In addition, group children in a tight bunch so that their heads are close together. It may not feel completely natural for them to be so close together, but it will look completely natural and give you a better overall picture.

WHAT TIME OF DAY IS BEST?

I've already said that morning and late-afternoon light is best for photos, but there's another element that's crucial in determining when to shoot. At what time of day is your child in the *best mood*? Only you can answer that, but I do recommend taking that into consideration when planning any picture-taking.

For toddlers, taking a photo right before nap time is guaranteed to frustrate both child and parent. Maybe your teenager isn't a morning person and doesn't offer any coherence until well after lunch. Be familiar with the timeline of your kids' moods and increase the likelihood that they'll be happy, cooperative, and photogenic.

When compared with the one opposite, this photo at left shows how much less inviting an image can be when the children are haphazardly placed.

▸▸ Look for Contrast

Imagine for a moment that you could step into your child's three-year-old body and look through his or her eyes. How large would the refrigerator seem? What about the dog that's suddenly at your eye level? And how would you even attempt to mount the toilet? There are so many tools we use daily that are clearly obstacles for small children. Look for ways to illustrate in your pictures just how your kids fit into this large world of ours. It will enlighten and often amuse you.

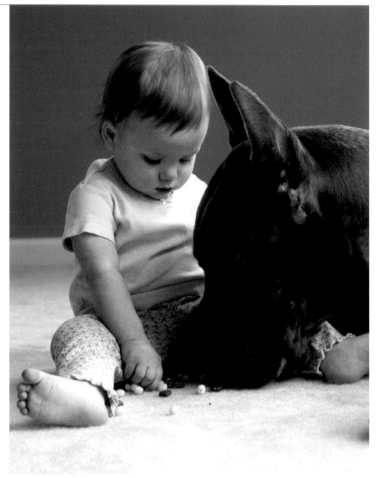

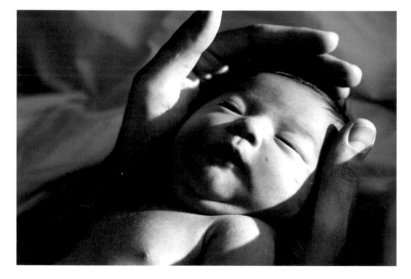

The tiny stature of this newborn will be quickly forgotten as she grows rapidly over the coming weeks. Incorporating dad's hands as a wrap for her gives an accurate perspective on her size, leaving this photo a favorite reminder for her parents. The dramatic lighting was easy to create: I used the late-afternoon light coming in through a window next to the bed. You can, too.

This little girl doesn't seem concerned that her best friend's head is as tall as her entire upper body. She seems more focused on getting her fair share of the cereal. I've got five bucks on the dog. Getting on your child's level is critical to showing size contrasts.

Great eyes and a great smile make for a great shot. But the brilliant date stamp on the bottom right rivals the neon glow of the Las Vegas skyline. Make sure you turn it off. *Photo © Ann Marie Gwaltney*

▸▸ Turn Off the Automatic Date Stamp

Several years ago, cameras started offering a feature that would automatically imprint each picture with the date the photo was taken. This is a clever way to keep track of dates and children's ages, but there's a big problem with this feature. It doesn't imprint the paper; *it burns the date into the negative.* What that means is that short of expensive computer retouching, there's no way to remove the date from the photo. Imagine taking the perfect picture of your child and having it permanently scarred by a digital date. Fortunately, with the advent of digital cameras, all the identifying information is stored within the photo's code.

Generally, the exact day a photo was taken matters less than the month or time of year, and that's easy to write down. So, turn off the automatic date stamp, pick up a pen, and just write the date on the envelope you keep your photographs in. You'll be glad you did.

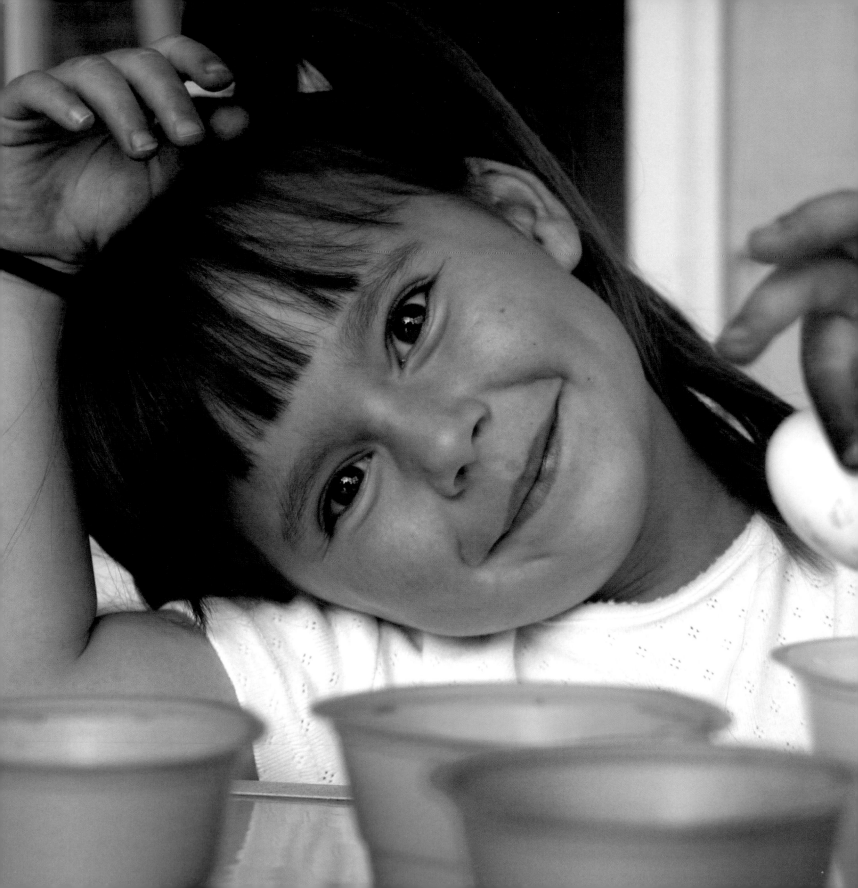

Part Two
Capturing
Special Moments

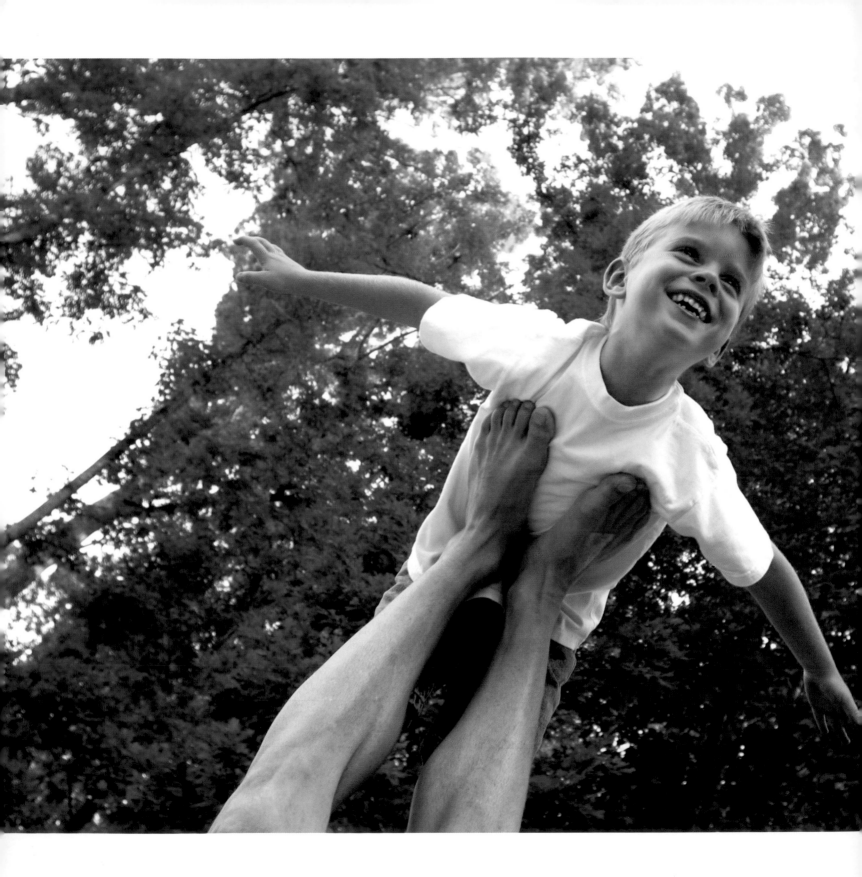

Great Candids

As our children age, they become mindful of how they're seen in the eyes of those around them. That awareness often dictates how they allow themselves to appear in pictures, leaving parents with predictable, static images. Though acceptable for some photos, most parents also want to remember the vivacious personality and endearing expressions of our children. Candid photos do just that; they see through any posturing, exposing our children's authentic character. A great candid photo is the Holy Grail of a parent's photographic quest. So, how do you get it?

▸▸ Keep Your Camera Nearby

First, your camera must be readily available. Think about where your camera is right now. Is it easily accessible? It may sound like common sense, but you'll miss many candids simply because the camera isn't within arm's reach. By the time you dig it out, the moment is gone. Take your camera out of the closet or cabinet, and leave it on the kitchen counter for a week. Come up with three or four places you can put your camera that will be easy to get to; think about where you spend time with your kids, and keep your camera close.

Going to the pool, park, or ball field? Put the camera in your car or handbag. You'll be ready to take many more candid photos if you have your camera nearby. You don't want to miss a fleeting photo-op because you couldn't quickly lay your hands on the camera.

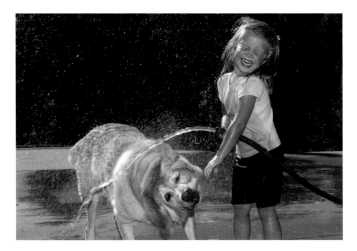

There are a few sure things in life: death, taxes, and a dog shaking off after a bath. You know it will happen, so be ready for it. Notice that the sun is slightly behind the girl and dog, making the water droplets gleam. Turning on the flash here helped to freeze the action and to adequately light both subjects on a bright day.

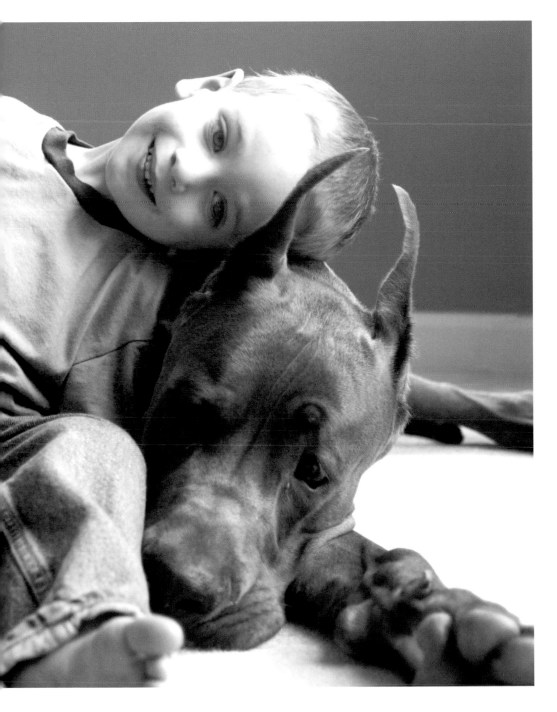

Though the dog outweighs the boy by over 150 pounds, they still view each other as peers, and their daily interaction makes for many priceless candid photo opportunities.

Virtually every picture of a toddler or baby reflects a candid moment.

▸▸ Occupy Your Child

With camera in hand, get your kids involved in what they love to do, and use your knowledge of their tendencies to predict their next moves. You know best when a certain joke or action will result in your favorite expression. Be ready for it, and keep your eyes open. The best scenes aren't staged but rather are snagged as life passes by.

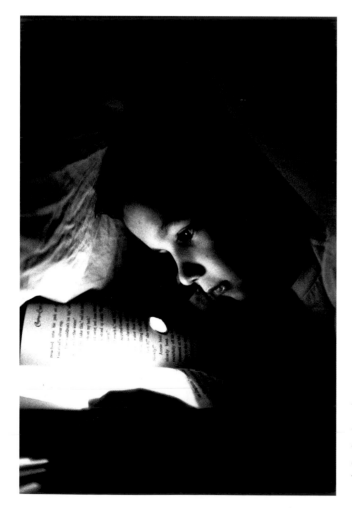

A healthy diet of silly string makes for a memorably messy shot.

You have to be pretty stealthy to go unnoticed while your child avoids bedtime, but it helps to know what transports your child to a world beyond distraction. Observe what activities completely absorb your children, and then use those times to enter their world to capture some remarkable scenes.

Position yourself in your child's line of sight while she's absorbed in her activity.

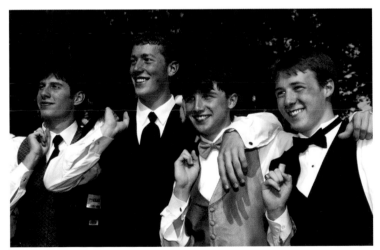

Motivated by their dates looking on, these Casanovas strut with good posture that surprises their parents. That they're posing for someone else actually makes this a great candid photo. Look for times when your kids are concentrating on something else; doing so yields great chances to catch genuine expressions.

CAMERA CURIOSITY

Some young kids seem to be consumed with curiosity every time you pull the camera out. They crawl or waddle over to the camera, disrupting the scene you were trying to capture. Without risking the safety of your camera, let them touch it and look through the viewfinder. This should satisfy their curiosity, and allow you to take their picture without them bolting toward you.

▸▸ Be a Wallflower

Kids seem to be keenly aware of when their parents enter a room, which makes our attempts at invisibility that much more difficult. There's no single fix to this problem, but take a lesson from your kids' classroom experience. Ask any school-age kids how to keep from getting called on in the classroom, and they will tell you to avoid eye contact. Try entering a room without speaking or drawing attention to yourself. See how long you're in your child's presence without him or her noticing you.

Once you've determined that you're not on your child's radar, snap a photo or two, but don't get carried away. (*Note:* If you're trying to be covert, nothing blows your cover like using flash. Make sure to turn off your flash before approaching your kids.) Once you've taken a shot, break eye contact, lower the camera, or act like you're concentrating on something else. Don't overplay your hand by staying too long. Your kids will learn that a quiet entrance by you has strings attached. You don't want your kids learning to react to you.

If sprinkles on cookies are good, why not go straight to the high-octane source? The boy putting the bottle in his mouth (near right) was a strong indicator of what was about to happen. Parents know their kids' behavioral tendencies better than anyone. Look for clues in your kids' actions, and you'll be prepared to snag the good stuff that follows.

Though still close to the nest, these kids have found a comfortable buffer from their parents who are grilling burgers on the deck above. All children reach an age when it's no longer cool to hang out with their parents, but it's still possible to take their picture in their "habitat" without being invasive.

GIVE A CAMERA TO YOUR TEEN

Give your teens cheap or disposable cameras to take with them on their activities. You'll be with them less and less as they get older, and this ensures that you continue to get pictures of them and their friends. They'll also exhibit a different range of expressions with their friends than many parents get to see.

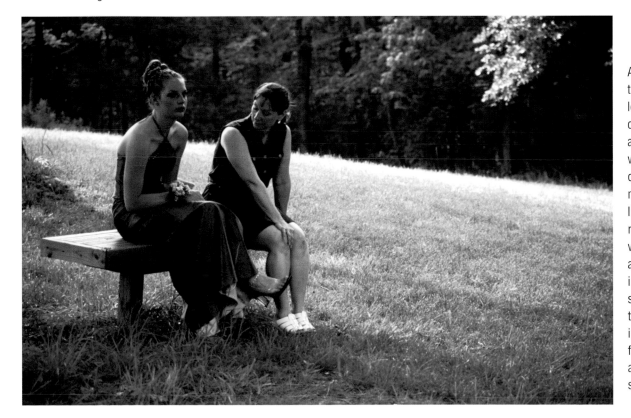

A lifetime of prom expectations sour when this girl learns that her date isn't coming. Mom and daughter are unaware of the camera, which enables the capture of the disappointment and makes the viewer feel more like a participant. Giving room in the frame for the woodsy green space not only adds to the beauty of the image, but increases the sense of isolation. Notice that there are no other elements in the extra space to distract from the emotional exchange, and the Rule of Thirds is successfully used.

▸▸ Don't Wait for a Smile

Here's a tip that will ease your stress behind the camera: Your child doesn't have to smile for you to get a great picture. What a relief! Smiles are great, but all parents know that their kids give them many expressions other than toothy grins. Daydreaming is a perfect example, and it's a great time to get your kids when they've let their guard down. What about the teenager lost in a book, or a kid with a wrinkled brow solely focused on the crayon and paper before him? Your scrapbook isn't complete without shots of your kid taking a power nap or crying over the latest disappointment. Here's the point: Don't feel like you have to wait for the magazine-cover smile before you snap the shutter. There are many emotions just as worthy of capturing. Look through this book to see how many good photos there are of kids who aren't grinning.

A timid girl and her friend find security in each other. I could have waited a long time for a smile and certainly would have missed this glimpse of their secret bond.

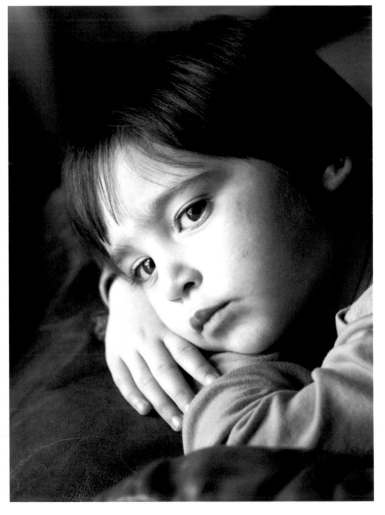

A rainy day can bring with it melancholy and a good chance for an introspective portrait.

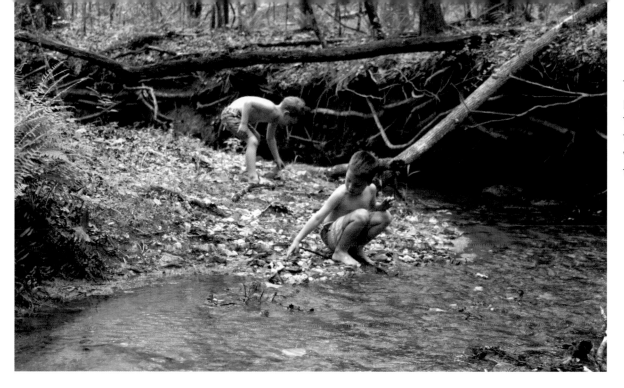

These boys were so completely absorbed in their play that I didn't want to disturb them for a pose. Smiles would have detracted from this genuine setting.

Unless you're a herpetologist, not even this newly caught snake can pull your attention from the boy's investigative gaze. From a parent's perspective, the boy's interest in the snake is more captivating than the snake itself, so locking in on his eyes was important.

KEEP AN EYE ON YOUR CHILD

What's the first thing that happens when your child accidentally lets go of a balloon? That's right, the entire family watches it ascend and disappear in the sky. Next time, think to watch your child's reaction to a circumstance rather than the circumstance itself. You've seen escaped balloons before, but you're only given a few years of expressive faces filled with the wonder of discovery.

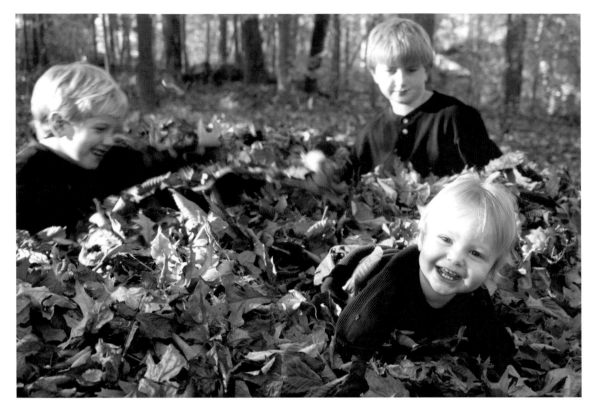

Few things equal the magnetic attraction between kids and leaves. You can bet there will be tumbling, wrestling, and laughing—and what's more, they probably won't leave the leaf pile. So, hang out for a while and be ready to snap.

▸▸Plan a Mini Photo Shoot

As parents, we've conditioned ourselves to react with the camera when our kids do something unexpected, like trying to wash the cat or cut their own hair. And this "just in case" mentality is completely justified; who ever said kids were predictable? Kudos to the parents who don't miss those elusive moments.

But there's another way you can increase your chances for great shots: by planning a mini photo shoot with your kids. This isn't a formal event with all the weary primping that goes with it. I'm talking instead about allocating thirty minutes or an hour each week with no distractions to have your camera in hand and just be with your kids. No phone, no e-mail, just them.

Play with them . . . take a snap, read with them . . . snap, wrestle with them . . . snap, tickle them . . . snap, tell jokes with them . . . snap, snap; you get the idea. Sometimes, just spending uninterrupted time with your kids brings out great chances to take pictures.

There'll be times that you'll walk away with ten keepers and other days with nothing. The point is that you're creating relaxed opportunities to use your camera on them. You're not rushed, and your kids aren't stressed. Think back to how many times you've bribed or threatened your kids to cooperate for one more shot. Have those bribes ever gotten you the keeper you were after? It's fine to have a loose plan, but be willing to ditch

your expectations. Blown expectations are often a stress inducer, so why let them invade on this personal time? Let your kids be themselves, welcoming whatever they want to do or talk about. More times than not, you'll end up with some great shots—and a happy kid.

And, here's the best part. Even if you don't take a single shot, you've just spent some quality time with your kids that you might not otherwise have had. That alone is more valuable than any priceless photo. Schedule this time with your kids. Only good can come of it.

Be willing to ditch your expectations.

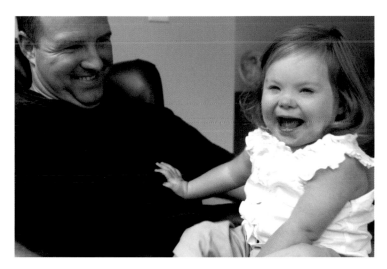

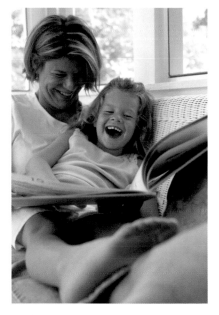

A little quiet time together turns into a laugh worth remembering.

If your children are posing for you, be ready to shoot the candid moment that appears between poses.

Kids love Saturday mornings with mom and dad. With cartoons and e-mail turned off, a ready parent will be able to capture the simple pleasure of spending time together. This picture will almost certainly remain on the mantel long after the school photo is stored in the shoebox.

If you are always one second late trying to get that perfect expression, lock the focus (if your camera allows) on your subject ahead of time so that you can shoot the picture at precisely the right moment.

▸▸ Say Anything but "Cheese"

What's the first thing kids say when prompted to smile for a photograph? That's right, "Cheeeeese." Snapping a photo while someone is saying "cheese" is the surest way to achieve a cheesy picture. Saying "cheese" puts the mouth in an unnatural position and makes smiles look forced.

Remember that your goal is to capture the most natural looks from your children, and sometimes that doesn't even involve a smile. But when it does, you want it to be a smile that's produced from genuine happiness, not "cheese." So, how do you get them to provide a perfect smile when you really want one? Kids seem to be happier when they know what's going to happen. Before you pull the camera out, say something like, "I'm going to take the camera out, and this time I'd like for you to show your great smile." That prepares them for what's about to happen and instills that your expectation applies to this time only. Consider telling a joke or saying something that tickles their funny bone, or just be happy with whatever expression they give you.

In general, it's always a good idea to let your kids know what is about to happen to them. It gives them an extra measure of security, and they're usually much more receptive and cooperative come picture time. This is true for toddlers and especially for teens and preteens. When possible, give them advance notice of a couple of hours or even a day, and be clear about your expectations. They will appreciate the extra time to emotionally prepare and to plan their wardrobe.

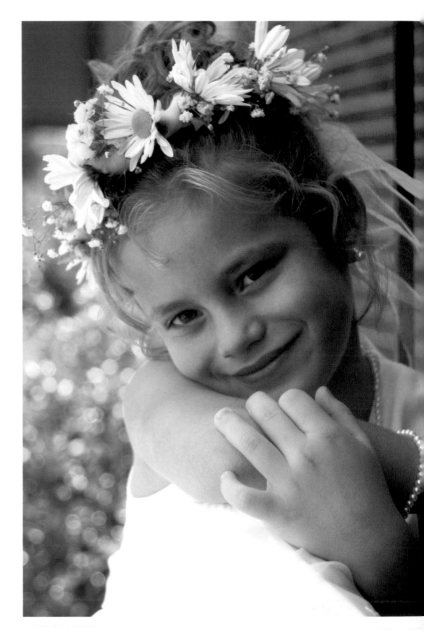

UNSTRIKE A POSE

Think about the routine you've established with your kids when you pull out the camera. Do they primp, make a face, or strike a pose? That can become frustrating when you're trying to get a candid shot and they keep sticking their tongues out. Regrettably, parents are usually to blame for that response. We've trained them to look at the camera and give the widest smile they can, but in so doing we've sacrificed the likelihood of catching them relaxed. The presence of a camera acts as a trigger for a certain kind of behavior, and our kids respond to our expectations of "auto-cheer."

You may want to try a little retraining to get back on track. Over several days, try pulling the camera out with no intention of taking a picture. Have a regular conversation with your kids while the camera is clearly visible. Then try to point it at them casually, again without taking a picture. Disengage when they start "performing," and casually bring them back to a point where they forget about the camera.

The next step would be to try to take a few photos, still with no expectations. If your kids start to rev up the act, quickly pull the camera down so that they recognize their clowning resulted in no interest for a picture. You know best how your child responds to different types of influences, so modify this approach as needed.

The point is for them to learn that you're interested in them just being themselves and that they don't have to change their demeanor when they see a camera. Pretty soon, they'll realize that their performance isn't winning them attention, and they'll lose interest. Once your kids are no longer aware of the camera, you'll be much more likely to capture some truly candid moments.

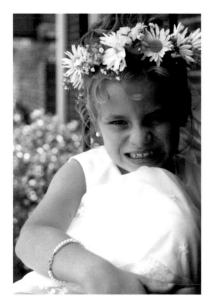

This flower girl, tired of processing "cheese" for the wedding photographer (below), reserved a genuine expression for mom (left). And, it certainly helped to take off those uncomfortable patent leather shoes.

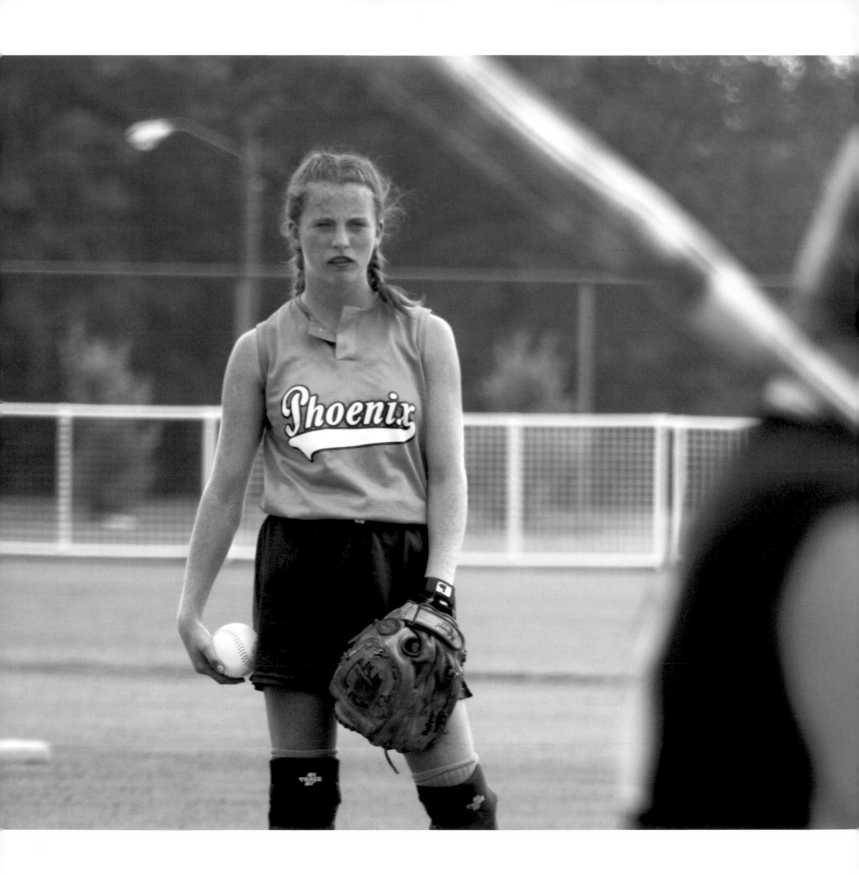

Sports

There's no doubt about it—we are a society of sports nuts. We watch, we cheer, we play, and then we have kids and sign them up. These days, local sports leagues offer athletic programs to children barely out of diapers. Even from the time our kids are crawling, we're putting footballs, baseball gloves, and tennis racquets in their hands in the hope that they'll enjoy sports as we do.

Children have the wonderful ability to compete with a reckless ferocity that morphs instantly into a goofy demeanor at the offer of a milkshake. This intense emotion and genuine playfulness, and even the quirky combination of the two, make for great pictures. And with so many hours spent on the playing field, you'll want to get some winning photos of them at each stage of the game.

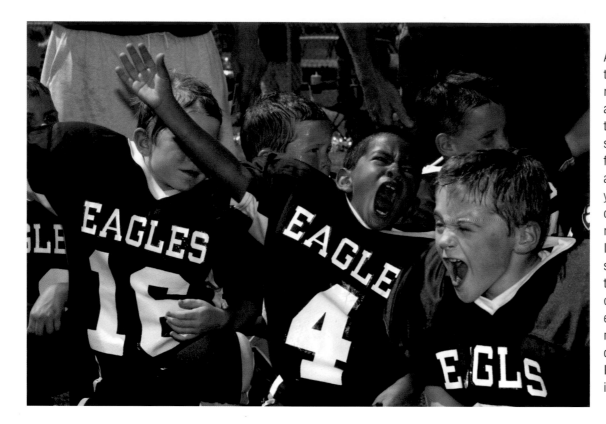

At the sound of the half-time whistle, the players retreated off the field and the parents headed toward the concession stand. I resisted the urge for a healthy corn dog and instead followed the young warriors to their coach's corner for a review of the game plan. I was expecting a loose scene of playful boys trading jabs and thumps on the arm. The surprising enthusiasm and war cry made me glad I had my camera—and relieved I wasn't opposite them in the second half.

▸▸ Focus Off-Field

There are some great photos to be landed at our kids' sporting events, and unfortunately, we miss most of them. The reason is that we parents try to mimic the spectacular action photos seen in sports magazines, but in reality many sports photo-ops happen off the field. In trying for that perfect shot of the touchdown catch, we miss the many other times our kids are interesting and expressive. A thousand things must be perfect to get that great action shot, and the odds are against us most of the time.

Remember, you're full-time parents, not photo-journalists. Your goal is to try to capture your child's spirit, and often the antics on the bench are much livelier than what's happening on the field. So start by focusing less on the field as a whole and more on your kids at play, between plays, or on the bench. Make it a point to occasionally pull your attention from the game to watch what's happening with the players on the sideline. It puts you in a great position to catch emotional outbursts such as tense anticipation, exasperation, despondence, and jubilation. Hang out next to the dugout or on the sideline, and just watch the emotional ebb and flow. A great photo of your kid is not dependent upon them actually hitting or catching a ball. Sure, you may want to record your son's great pitching form for posterity, but don't miss out on the vast display of expressions kids offer before, during, and after their games.

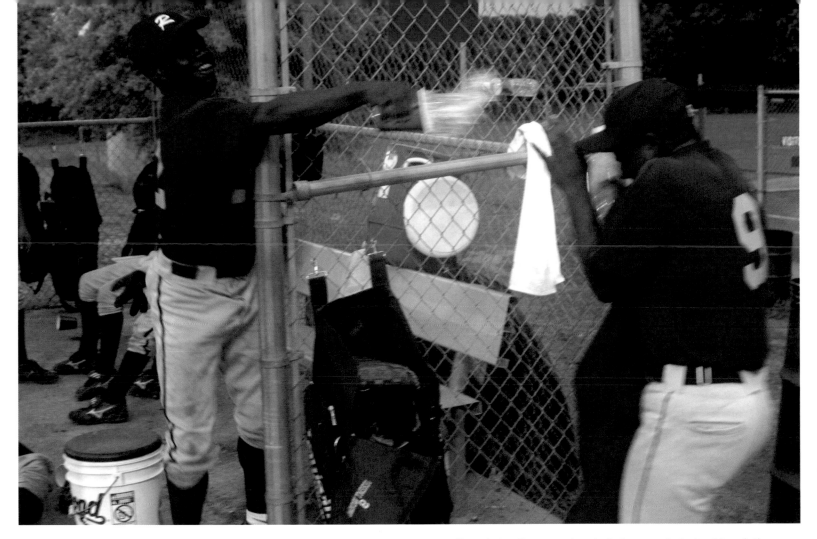

Even during the game, baseball players get plenty of bench time, and where there's time, there's mischief. Here, a player who has had enough sunflower seeds in his Gatorade gives a bath to his guilty buddy. Stay close to the bench. You'll be amazed at how many chances you'll have to take pictures during just one game.

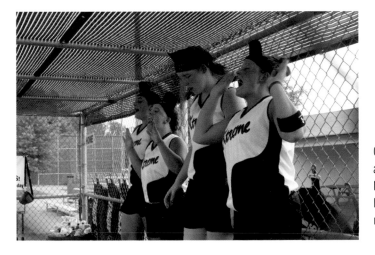

Get as close to the fence as possible to get your lens through the chain link. You don't want to miss the rally cries!

Often, the antics on the bench are much livelier than what's happening on the field.

Before you give these girls a lesson in applying makeup, try to appreciate the number of bases they've slid into during the course of the day's tournament. This war paint is proof of their effort. Consider which photo you'll appreciate more over the years: the team picture with the white, pressed uniforms or this grubby record of dugout camaraderie.

Two factors could have derailed this picture before it happened: positioning and strong midday sun. I saw that this player was getting an up-close-and-personal discourse from the coach, so I got in his line of sight—instead of shooting from the side—to better capture their connection. With the thick helmet covering the boy's face, I knew the midday sun would cast his eyes in shadow, so I simply turned on the flash and found his eyes.

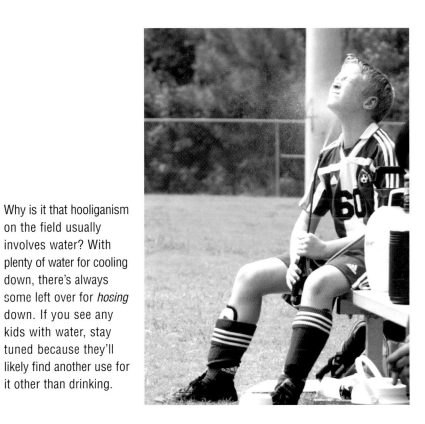

Why is it that hooliganism on the field usually involves water? With plenty of water for cooling down, there's always some left over for *hosing* down. If you see any kids with water, stay tuned because they'll likely find another use for it other than drinking.

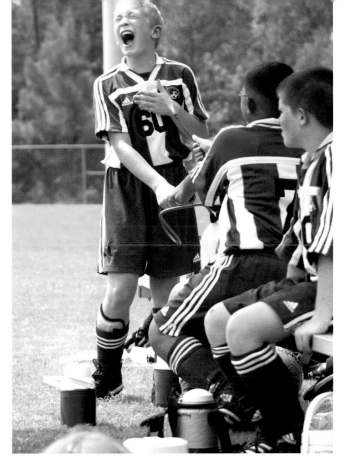

Don't hesitate to pull your camera out at your child's despondent times. These times serve as reminders of just how seriously our kids take competition and of how their maturing egos are still quite fragile. The intense emotion of disappointment quickly fades and is usually long forgotten at the ice cream parlor after the game, so grab the fleeting moments while you can.

▸▸ On-Field Action

So, you still want the action shot that records your daughter's model golf swing, or your skilled soccer-goalie son stretching out to save a game-winning goal?

Professional sports photographers do have a distinct advantage because of their training and high-performance gear. But you have something more valuable that no professional has in his camera bag: intimate knowledge of your child's tendencies and behavior on the field. I call this *educated anticipation,* and it is paramount in capturing a winning action shot. It means knowing what your child will most likely do in a given situation. It enables you to be ready for the action before it happens. Think about how your child likes to play the game. Factor in the team's game plan and your knowledge of the plays, and you'll be more than prepared to snag a great shot.

Another advantage for the parent over the professional is that you're not responsible for recording the actions of many different players. You can focus your attention on one subject throughout the game, and that dramatically increases your chances of getting a keeper.

Note that I crop many of my action shots to overcome some loose shooting during plays. It's always an option. Don't feel like you must have every shot composed perfectly in the frame to get a keeper; just try to freeze the action, and shape it up a little later with cropping.

Swimming photos are actually quite easy to take. Just apply some lessons from previous chapters: Get at or below eye level and give your subject room to swim.

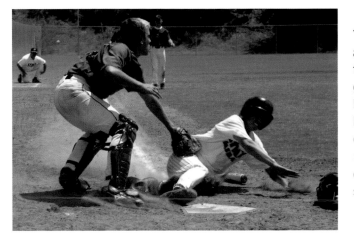

Your son's on second base, and you think he'll attempt to score if the current batter gets a hit. If he gets that hit, be ready for a slide at home by prefocusing your camera on home plate. You'll be ready to snap the shutter at exactly the right time as he slides into focus.

WHAT NOT TO DO

What's this a picture of? It's anyone's guess. Resign yourself to leaving the comfort of the stands for just a few minutes each game to get close for some good pictures. Try moving to different locations around the field, and put your lens through the fence. That will make the viewer feel less like a spectator and more like a fellow player on the field.

Be mindful of your background. If you don't, spectators and players may meld together so that the subject isn't clearly defined—and the impact of the players is lost.

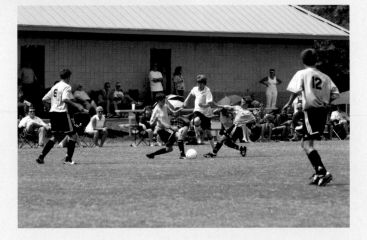

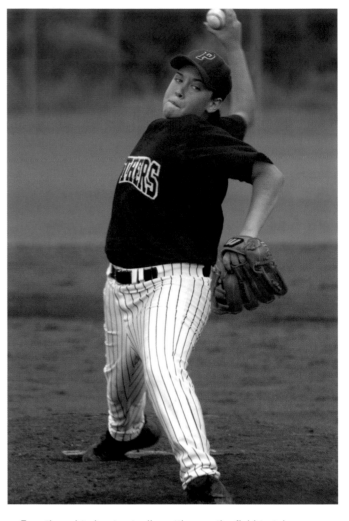

Getting a picture of your child dribbling the basketball should be easy, right? Yes, but . . . remember to press the shutter at the moment that the ball is in your child's hand. Snap at the wrong time and you'll be left with a ball glued to the floor and an awkward photo. The same approach is true for shots of players actually shooting a basket; take the picture *before* the ball has left their hands. Above you can feel the natural action of the player driving for the basket, while in the image at right the ball seems dead on the ground.

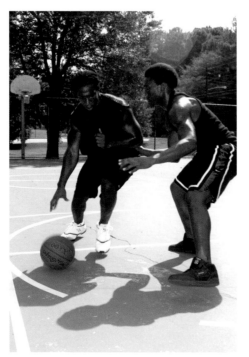

Ever thought about actually getting on the field to take pictures? With permission, most coaches will let you walk around on the field during warm-ups, so get on the field prior to the start of the game and get some shots of your kids preparing. You'll be able to get closer to the action than you can when the game starts. Remember to take extra snaps to make sure you get the keeper; I took at least eight shots of this boy to get just this one keeper.

Be ready for the action before it happens.

There are many sporting events during which you can get close without impeding play. You can't see the net in this lacrosse photo, but I was just behind the goal. The action is generally intense any time players approach their opponents' goal, so I hung back and waited for the action to come to me. It wasn't long before a daring girl got triple-teamed in the red zone, and a clash ensued (above).

A player doesn't have to be attempting to score for the action to be exciting. The girls' flying hair (right) is an indicator that they're at a full sprint. You get the sense that they're all alone on the field and that the contest is all or nothing between just the two of them. Notice that there's a little room ahead of them to give them room to run.

Cheerleaders are great photographic subjects because the whole purpose of their sport is to be expressive and motivated. You can also get closer to them than you can to some other athletes, so move in for a tight shot when possible.

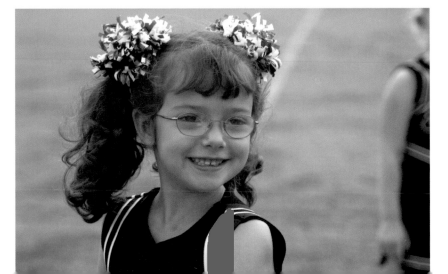

To prepare for a shot, think about how your child likes to play the game.

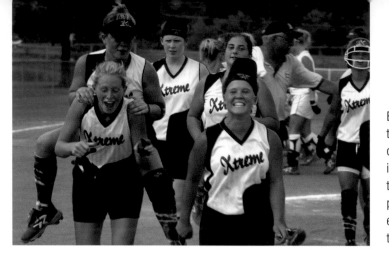

Be ready with your camera toward the end of the game or just after it's over. This is usually the moment with the highest emotion, and the players are more likely to exhibit expressive behavior that's great for pictures.

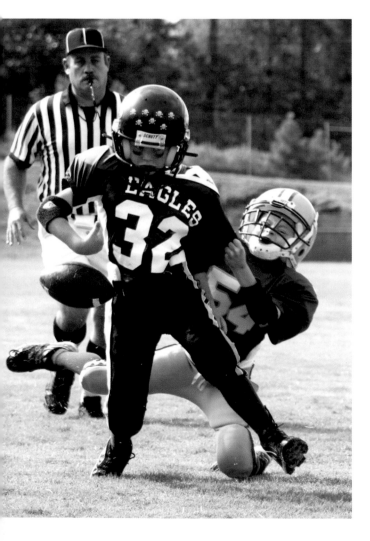

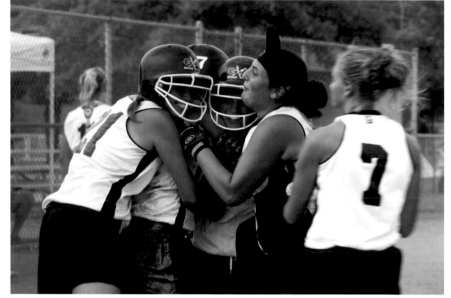

At six years old, these peewee players are no less intense than their professional counterparts. This picture didn't take any more than five minutes to get. With the coach's permission, I simply stood on the sideline between two other parents and waited for the play to come my way. Shooting downfield also minimized the number of distractions that appeared in the background, as opposed to shooting across the field to the other busy sideline.

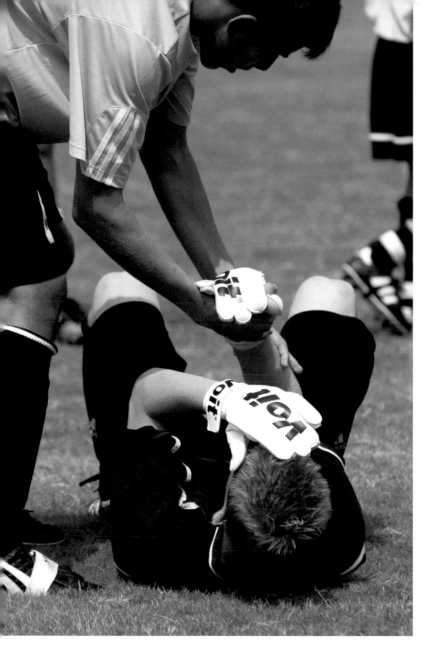

The weight of his teammates' hopes is heavy for the one guy responsible for keeping the goal clear. Jubilation after a score is a great emotion for pictures, but equally as moving is the acceptance and helping hand after a failed play. That's why they play the game, isn't it? To learn how to win . . . and also to lose.

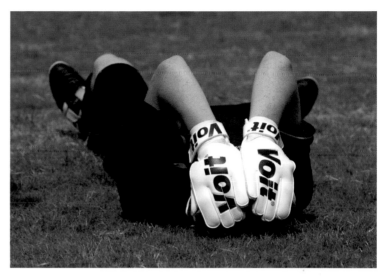

Some of the best action shots are a result of pressing the shutter button just before the action happens. Practice pressing the shutter as your player winds up to kick the ball. If you wait until they kick it, you lose the anticipation of what might happen and are likely left with a blurry mess. As a fan watching the game, you're interested in where the ball goes after the kick, but as a photographer, you need to freeze the action early to create the greatest drama.

POSITIONING TIPS

Football

- If your son is a receiver, learn his routes. Know his intended destination point, and be familiar enough with the plays to know where the thrown ball will meet him so that you can catch him at the moment of reception.

- If your son is playing on the offensive line, position yourself a few yards ahead of the line of scrimmage. The play will be moving toward you, and you'll be in the best position to shoot it. If he's on defense, then stay behind the line. You want to be in a position that'll let you see his face most of the time.

- Increasing your knowledge of certain sports, especially football, increases the likelihood that you'll be in the right place at the right time. If it's third down

and long, you can bet your team will pass and not run. You won't guess right every time, but the odds will be on your side.

Baseball/Softball

- If your child bats lefty, go to the third-base side of the field. The batter watches the ball coming, and that lines his or her face up with the opposite side of the field. For right-handed batters, go to the first-base side.

- If your child is pitching, try lining up behind the catcher for a head-on shot. Also try moving halfway up the sideline (to third base, if he or she is a right-hander). This perspective may better illustrate pitching form and reveal more of the face.

- If you think your child might attempt a slide home, focus on home plate and wait for them to cross. You'll have already composed and prefocused the picture, freeing you up to snap the shutter at the right time.

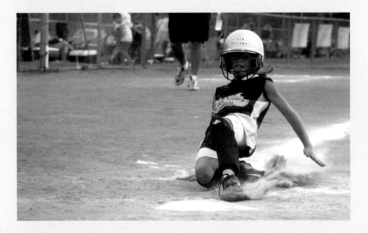

- If your child is a base runner on second or third, move behind home plate; most any hit will generate an attempt to score, and you'll be ready for the plate shot or the enthusiastic greeting from teammates. Or, try capturing your child rounding third; taking the risk to try to score usually generates intense facial expressions.

Basketball & Gymnastics

- Sporting events in gymnasiums are usually afflicted with poor lighting. Don't shoot in the middle of a jump shot or double flip unless you have very fast film or you're allowed to use a flash; doing so almost guarantees a blurry picture. Instead, look for action that isn't high speed, like a player who's about to drive the ball toward the basket.

- For gymnastics, wait until that split second at the end of a routine when a gymnast holds his or her arms at attention as if to announce that the move is done. There's still action in the accomplishment of the move.

 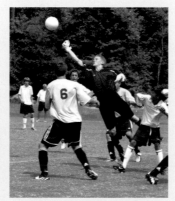

Soccer, Lacrosse & Hockey

- If your child is playing offense in soccer or lacrosse, stand a safe distance behind the other team's goal. If your child plays another position, get yourself close to his or her running path. Since you can get so close to the sidelines in these sports, you can come within just a few feet of players.

- For soccer, take the picture just prior to the kick—with the leg cocked—for greatest interest.

Miscellaneous

- Whatever sport your child plays, put yourself in position to see his or her face.

- As a courtesy, ask permission from the coach to get a little closer than normal. As long as you're not interfering, coaches are usually more than happy to accommodate requests. Since some coaches are accustomed to dealing with belligerent parents, they also tend to extend an extra measure of grace to parents seeking to work within their guidelines.

- Be aware of what's going on behind your subject. Athletic venues have a surprising number of light poles, brightly colored shirts, and a host of other elements that will distract from your subject.

- If your camera will let you, set it for a fast shutter speed. That'll help freeze action and reduce blurring. If you don't have that option, try using faster film.

- Keep shooting. You'll need to take several shots to get that one keeper.

- Remember to give your child a little room to kick, throw, jump, run, swim, and shoot within the composition.

- When possible, stick your camera lens through field fences to get the closest possible picture and avoid fence wires.

- Keep your camera on your child, not the ball. It doesn't matter where the ball travels if your child isn't part of the play. Also, following the ball increases the chances that your picture will be out of focus or blurry.

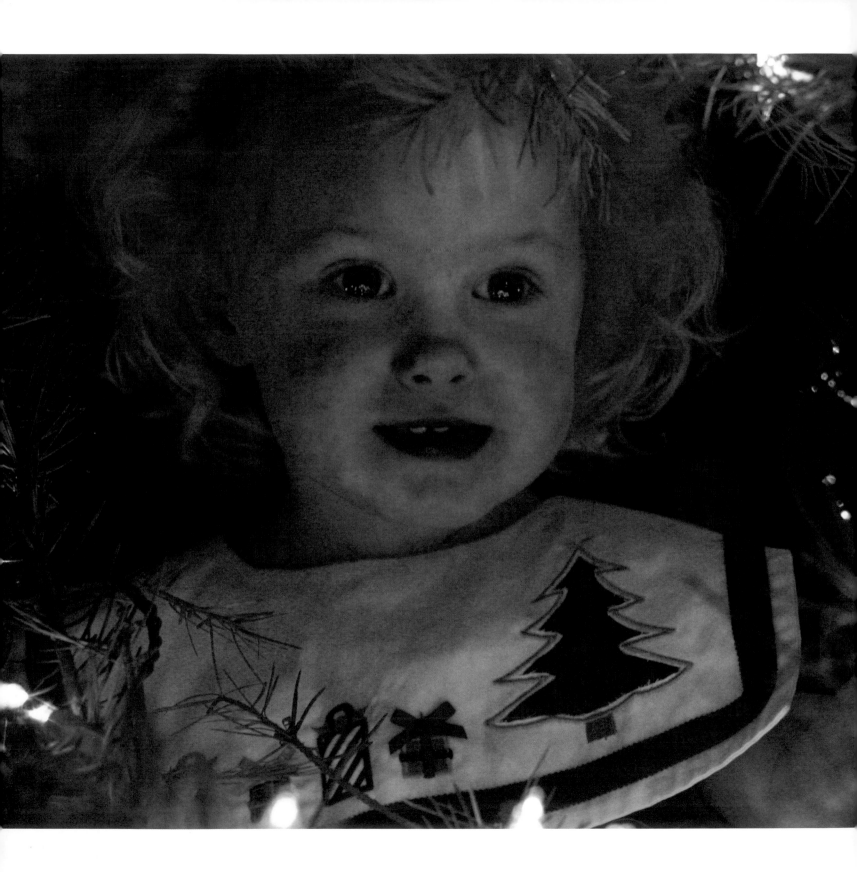

Special Occasions

So you've practiced all the previous techniques, and now you're faced with a special occasion, like a birthday or holiday. What's different photographically about these situations that could prevent you from getting that incredible photo? What else do you need to know? Nothing. You're ready. Nothing has changed except the day of the week, so just apply what you know.

Special occasions are often accompanied by related elements or decorations that act as helpful identifiers. With Easter, it's the bright colors of dyed eggs. On birthdays, it's the cake and party hats. Regardless of the event, remember to incorporate these elements in moderation, so as not to overpower the subject—your kids! They are still the most interesting part of the photo.

▸▸ Birthday Parties

The standard picture—blowing out the candles—is still a goodie, but a little planning can make the shot more memorable. Most shots like these show guests sitting at the table facing the birthday child, which results in a view of the backs of many heads and the blower facing the camera all alone. Take ten seconds to position the other kids around and behind the birthday child so that you can see all the kids participating in the celebration within the picture.

And don't forget to keep an eye on other party activities. You will come away with a fuller record of the day's events.

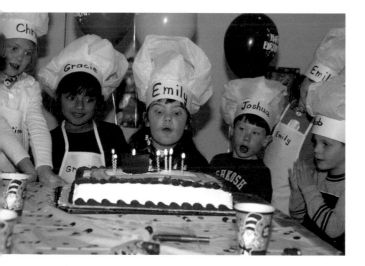

Grouping kids together in photos (see page 80 for more on this technique) results in fuller, more satisfying images.

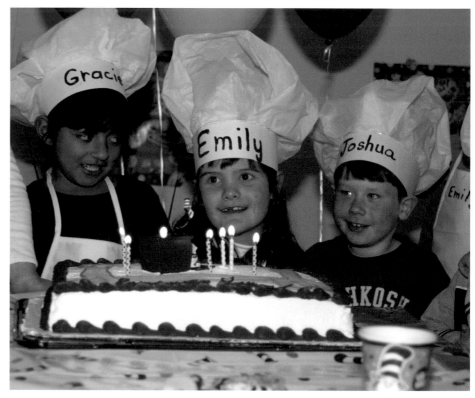

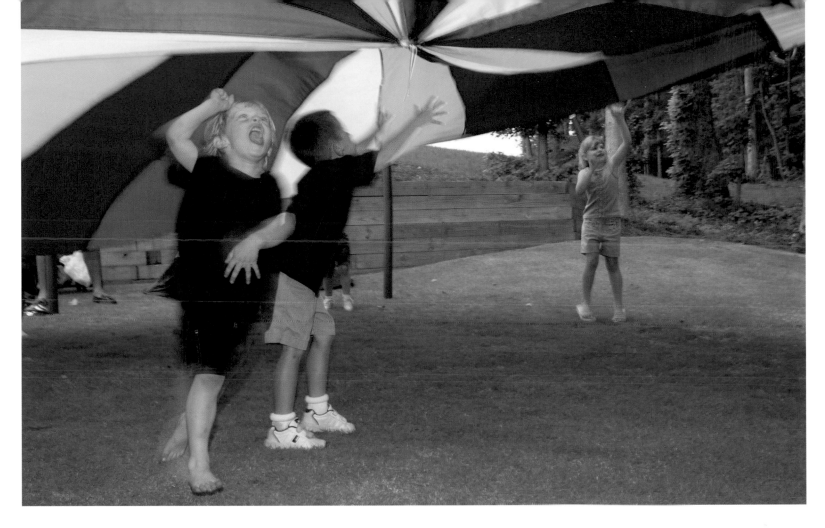

Look for ways to jump into your child's perspective by staying on his level. Doing so made the parachute in these pictures as large as a house, and the bright colors strengthen the overall image.

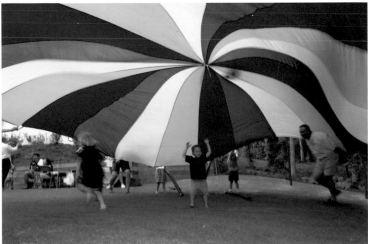

▸▸ First Haircut

Your child's reaction to his first haircut, or first trip to the barbershop as was the case here, is anything but certain. A smile would be great, but be ready for the more likely expressions of wonder, curiosity, and even terror.

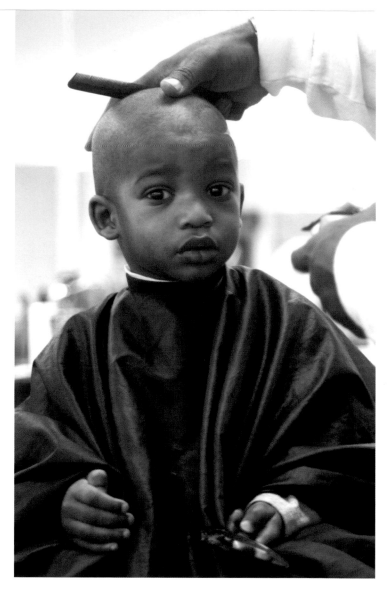

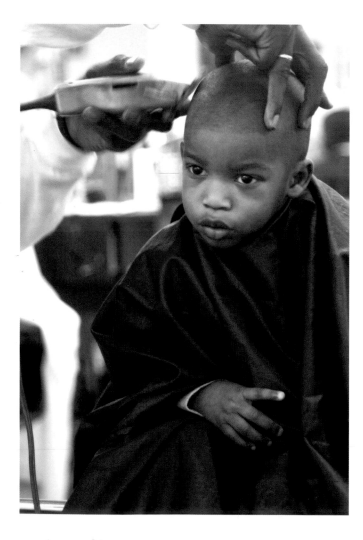

Keep shooting to get a variety of expressions.

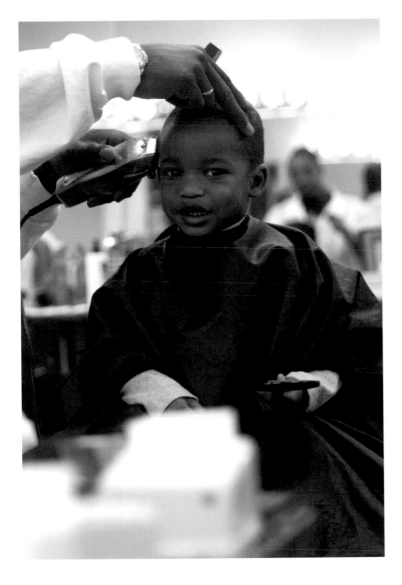

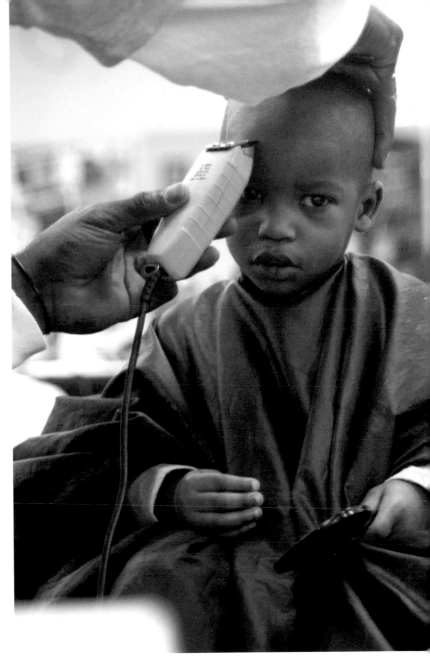

▸▸ First Day of School and Prom

In addition to graduation (see pages 20, 33, and 45 for examples), your child's first day and prom are other school-related events worth preserving on film. The first day of school is one of the biggest days of a young child's life. To parents, when their kids step on that bus for the first time, it's as if they're stepping onto an alien ship never to return. But they do—and grow into young adults. Prom signifies a coming of age and is yet another chance for parents to record their maturing children. Unlike at other times, teens are usually more than eager to have their photo taken while preparing for prom, so be ready to take advantage of their newfound interest.

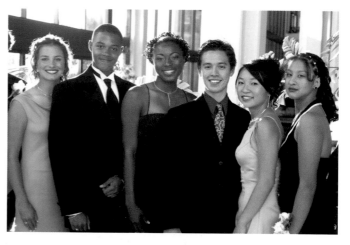

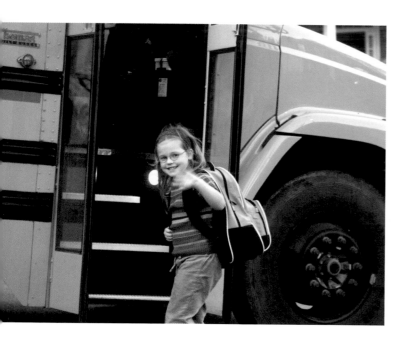

To this girl's parents, this first day of school is the start of the blurring chain of events toward her driver's license, graduation, college, and wedding. Getting down on the girl's eye level reinforces the enormity of the bus, as if it will seemingly swallow her up. Depending on the school district, school may start very early in the morning, so be ready with fast film to accommodate the low light levels.

The bold colors and elegant dresses of prom make for great subjects. Remember to group multiple kids close together, and place those in contrasting colors next to one another so that each person stands out more.

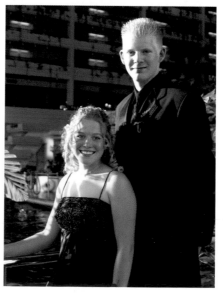

The humor of this stark height contrast overshadows even the euphoria of prom, and it also makes for a nice shot.

▸▸ Religious Passages

Have your camera ready for christenings (shown), first communions, bar and bat mitzvahs, confirmations, and any other religious rites you want, or are able, to photograph. Think ahead and park yourself near the front for a close-up vantage point. Fill the frame with only the participants to increase the personal and reverent nature of the shot.

Most churches don't mind the use of flash, especially during children's events, but this church had enough good natural light that I decided to use that instead.

▸▸ Easter and the Fourth of July

Spring and Easter are great times to take pictures of your kids. Many families hibernate for the winter, so the excitement of being outside exuberantly shines through in pictures. The colors are bright and the light is just right.

The Fourth of July is also a great holiday for picture-taking. The colors are bold, and because we traditionally drape ourselves, our kids, and our surroundings in loud patriotic adornment, there are usually great background elements built in to the images.

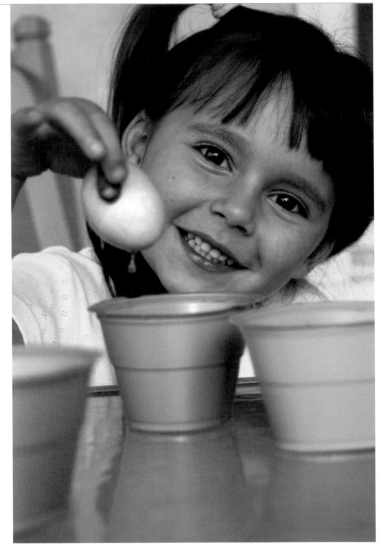

Coloring and hunting for Easter eggs are still great activities to catch on film. It's so important to remember to stay at or below your child's eye level. A child's focus on the egg can be so intent that standing above or behind your child can mean missing their fun experience. So get down on your knees and elbows, and put yourself within staining range of the egg dye to snap some truly memorable pictures.

The two flags in this image form a frame that surrounds the subject nicely.

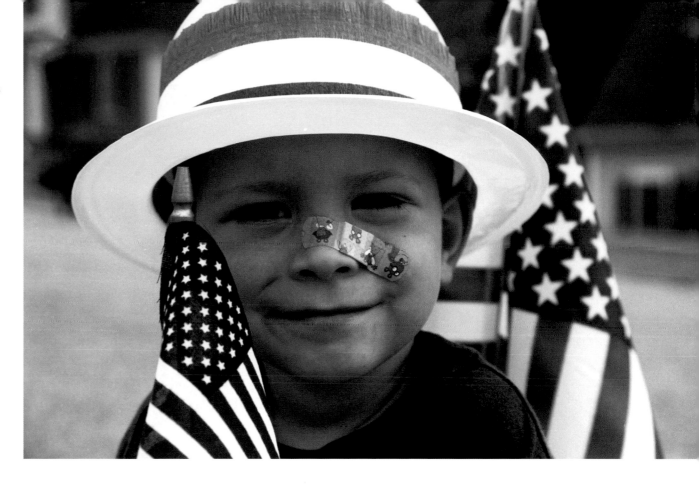

Remember to get close and keep shooting.

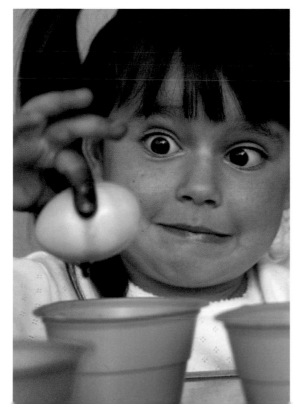

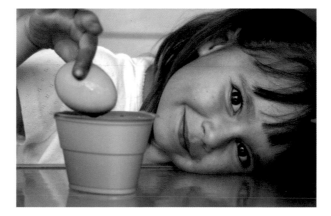

Notice in all these Easter shots that the egg isn't clearly in focus, but because the eyes are, the photos look just right.

▸▸ Halloween

The creative possibilities surrounding Halloween are clearly without bounds. Trick-or-treating usually begins after dark, so consider taking your pictures thirty minutes or more before sundown. You'll get your shot and your kids won't feel rushed to get to the candy action.

Like most other holidays, Halloween offers kids many activities, but you'll miss them unless you remember to stay at or below their eye level. The eyes of this bobbing Count are an important part of sharing in the experience.

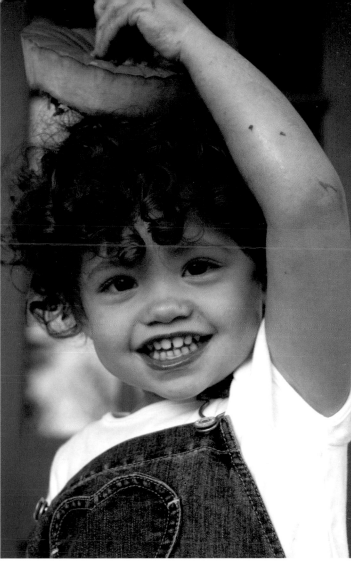

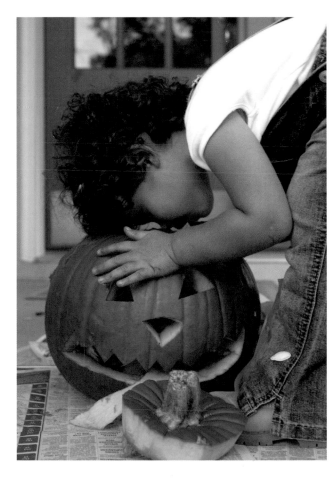

Kids love uninterrupted time with their parents. If you don't do it already, consider making pumpkin-carving (or a related fall activity) an annual tradition. It provides children with more anticipation for the season and gives you more chances to get great pictures of them. Since this activity involved mom and daughter looking down, it was necessary to get well below eye level to make sure their eyes were an integral part of the pictures.

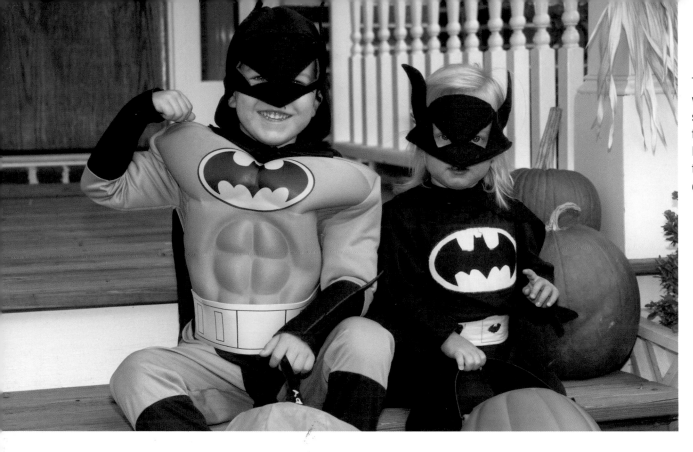

The world is a safer place with these crime-fighting siblings, charm being their primary weapon. Pose your kids close together so that you can get a tighter shot.

So, your kid begged to have a particular costume, but come showtime he doesn't want anything to do with it. Why fight it? This shot will probably get more life in your photo album because of how honestly it depicts a particular moment in his life. Don't be disappointed if your kids don't always give you a wide grin. What they do give you could be much better.

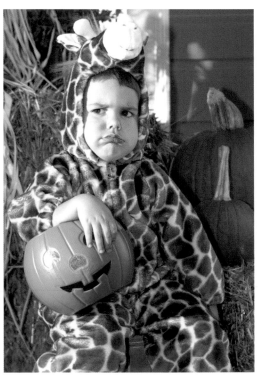

Beginning the picture-taking just before sundown ensures that you'll get plenty of shots of your kids before they get anxious to start trick-or-treating.

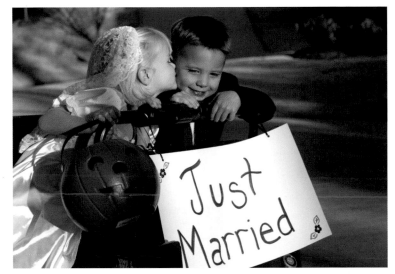

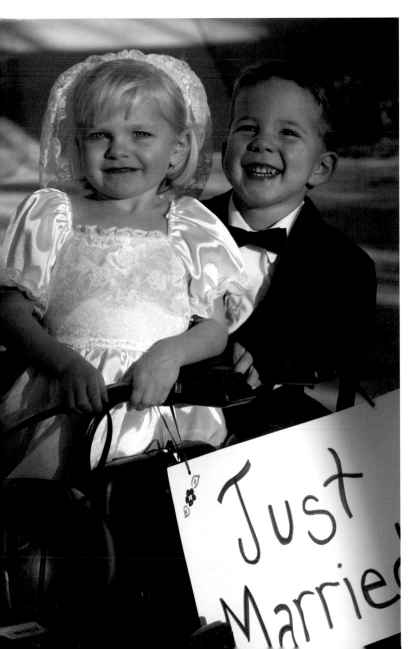

Trick-or-treating begins after dark, but take Halloween pictures before sundown.

▸▸ Winter Holidays

Family and relationships are what the winter holidays are all about. From Thanksgiving through New Year's Day, time slows down just enough for us to enjoy the simple pleasures of cooking family meals, opening presents, gathering with friends, and carrying on season traditions.

Take a quick account of the holiday photos you've taken, and ask yourself if they captured your family's true experience during those times. Most of us would likely say that we have an annual photographic record of our kids opening presents and Uncle Joe eating a giant slab of turkey, and that's about it. The holidays are such a good time to take pictures, but why are we so hung up on photos of kids opening presents? These shots hardly ever make it into the frame on the mantle, yet we continue to snap liberally as the wrapping paper flies. Most likely, this is because our mental landscape is filled with visuals of children intoxicated with excitement fueled by a few chocolate reindeer.

At Christmastime, we also tend to think that gift-opening festivities—and, therefore, photographic opportunities—begin within minutes of the children waking up. Rarely do parents even get the opportunity to take a shower before opening gifts. This year, spare your spouse the anxiety of snapping him or her with a bed-head coiffure. Try, instead, to capture the entire season of the holidays, including decorating the house and tree, wrapping presents, and other days and events leading up to the occasion. A child's anticipation can present many photographic opportunities.

And what about Uncle Joe? It's a safe bet that most people do not like to be depicted in the gluttonous consumption of a thirty pound turkey. Capture, instead, the cooks in the kitchen preparing the feast. Most often, the kitchen is where many families socialize anyway, so why not look there for warm camaraderie? Most kitchens also have more windows, which provide better light.

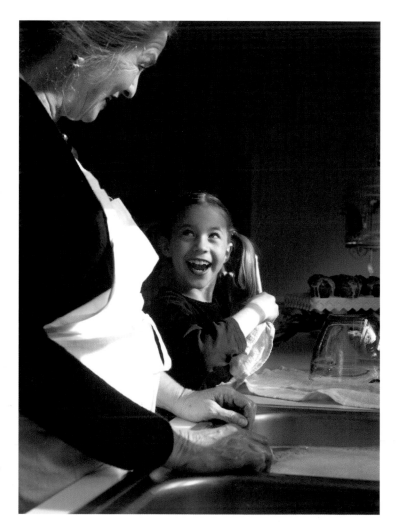

Around the holidays look for ways to capture the interaction between people, as in the obvious bond between this girl and her grandmother.

Look for elements unique to a holiday to get variety in your photos. Here, the warm light coming from the menorah candles and the reverence surrounding the occasion make for a wonderfully intimate shot.

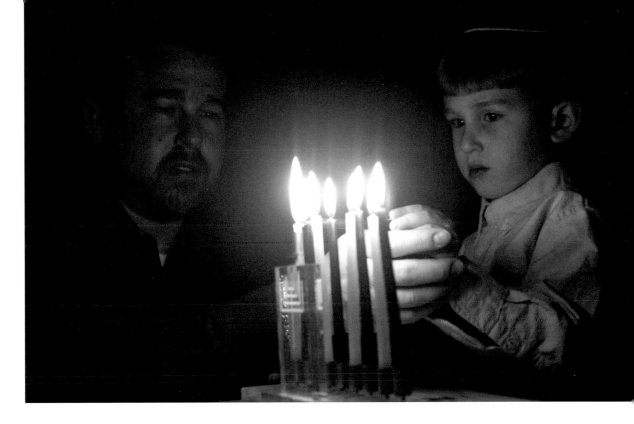

A shot of your child under the Christmas tree will nicely contain all the familiar holiday elements: tree and tree stand, presents and festive wrapping paper, and excited and happy facial expressions. Images like this one also make nice Christmas cards.

Framing these three hams within the wreath enabled me to include a familiar festive element, but it also enabled me to get close to capture their silly faces.

The reassuring warmth of hot cocoa knocks the chill off this blustery Christmas morning. Your kids don't have to be perfectly groomed for you to get winning photos of them. Be patient and watch intently for their personality to show through.

Opening gifts on Christmas morning is usually pandemonium. As an alternative, look for pictures in more relaxed settings, such as when *wrapping* Christmas presents. The results won't be predictable, but they will be warm and friendly.

▸▸ Pictures for Holiday Cards

The annual ritual of sending out holiday cards has changed. What was once a deluge of typical nativity scenes, gingerbread men, and snowy landscapes has now become something much more personal as families use pictures of their kids for this yearly mass distribution.

What's interesting is that parents rarely send out school photos. The family holiday photo almost always involves a whimsical holiday setting or holiday props or accessories. And, the recipients usually save the picture after the holiday season is over. These images find permanent residence on the refrigerator, in frames, or in albums and scrapbooks. Consequently, there's a new enthusiasm for sending out and receiving holiday cards. Why? We want to see the photos. We want to see how the kids have grown from last year and if their parents have lost those twenty pounds.

Fortunately, it's easy to take a great holiday photo. If you're this far into the book, you already know the main principles to keep in mind. But taking holiday pictures does present more landmines than the average photo. That's because we're trying to coerce our children into poses while also capturing the seasonal decorations in or on our homes. It's easy to forget what works in a picture, leaving the image a cluttered mess.

Simplicity is the best approach, and the primary objective hasn't changed: Your children should be the main interest in the picture. Lights, candles, garlands, the tree, reindeer, snow, and presents are all secondary to your kids, so don't worry about incorporating every holiday knick-knack.

The parents of this little girl don't live near a snowy mountain, so they used the only white stuff available to them: sand. Mom may have positioned the camera slightly higher than subject eye level, but in doing so she effectively removed the endless strip of beach condos that would have resulted in a distracting background for her daughter. She also added a dash of bright color with the Santa hat to give the picture some pop. *Photo © Cale Taylor*

HOLIDAY CARD PHOTO TIPS

- White Christmas tree lights are better than colored ones.

- Incorporate candles (carefully!); they make for a very warm scene.

- Introduce solid colors with greenery, red bows, or poinsettias.

- Against a snowy background, clothes in bright solid colors offer great contrast and drive home that holiday feeling.

- Remember to stay close.

- Black-and-white photography makes for a very elegant scene; textured—or even all white—clothing looks great.

- In colder climates, consider taking your photos in late summer or early fall, when outdoor temperatures are more comfortable.

- Change your camera batteries, have a few extra rolls of film or memory cards handy, and take lots of shots.

- Don't have time to make a photo card in the chaotic holiday season? Consider sending out a New Year's or even a Valentine's Day card with your child's picture in it. It will stand out at that time of year.

See for yourself the stark difference between this pair of holiday card photos. Comparing them while going over a checklist of techniques can help.

- Did I get close?
- Did I employ the Rule of Thirds?
- Did I use natural light?
- Are the kids wearing the right clothes?
- Did I watch out for the background?

The image above shows what happens when these few simple techniques are overlooked. The result is a drab, unflattering image. If you send a photo to your friends and family once a year, this is not the one you want to use. The image below makes use of all the techniques listed, and the result is much better. With multiple kids in the scene, remember to keep shooting so that you have a better chance of avoiding closed eyes and odd expressions.

Taking Pictures for Your Scrapbook

Scrapbooking has become one of the fastest-growing hobbies in the United States, and it's easy to see why. Parents are taking more pictures of their children than ever before, and are looking for additional ways to record and present their family's origins and activities. Scrapbooking provides them with unlimited means to creatively express themselves, and to display their family photos in a format as unique and distinctive as a fingerprint. And there's also a distinct way to photograph when you intend to use those images for scrapbooking.

▸▸ The General Concept

Many parents think of recording an occasion with one photo. Sometimes it's necessary to have all the aspects of an event represented in a single photo. For a birthday photo that you want to frame or send to family members, you'll probably want the child, birthday cake, presents, friends, and the clown in a single shot—if that's physically possible.

However, seasoned scrapbookers have learned to take a *series* of photos to capture the chronology of an event. They elongate an experience using multiple photos to create a storyboard that links minor events within the major one. They then frame those photos within colorful and decorative pages, and further illustrate the events with detailed captions and supporting materials like ticket stubs, bird feathers, autumn leaves, or whatever applies to that experience.

Instead of one photo illustrating that a birthday party took place, for example, you would have a series showing what made the birthday party fun and memorable. The photo of the excited birthday boy or girl leads to the one of the table covered with presents, which leads to the one of the birthday cake loaded with candles, and then to the one of all the kids coated in cake icing, and on and on. Here and on the next few pages are some examples of various scrapbooking subjects.

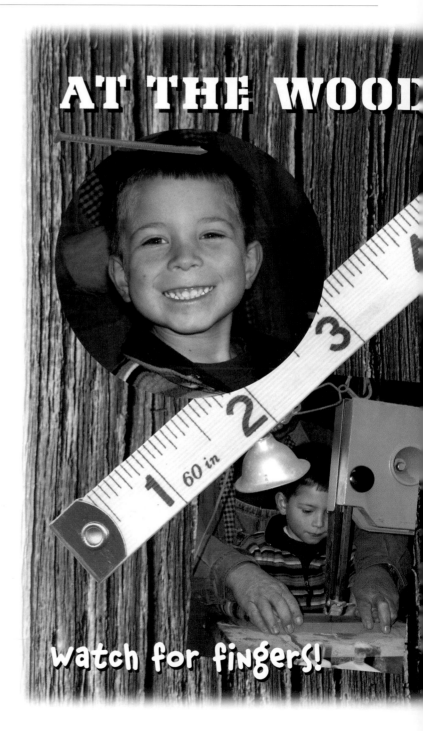

AT THE WOOD

watch for fingers!

WORKING SHOP

NOTE TO SELF: Do not hit thumb!

Today, a birdhouse.
Tomorrow . . .
maybe another
birdhouse.

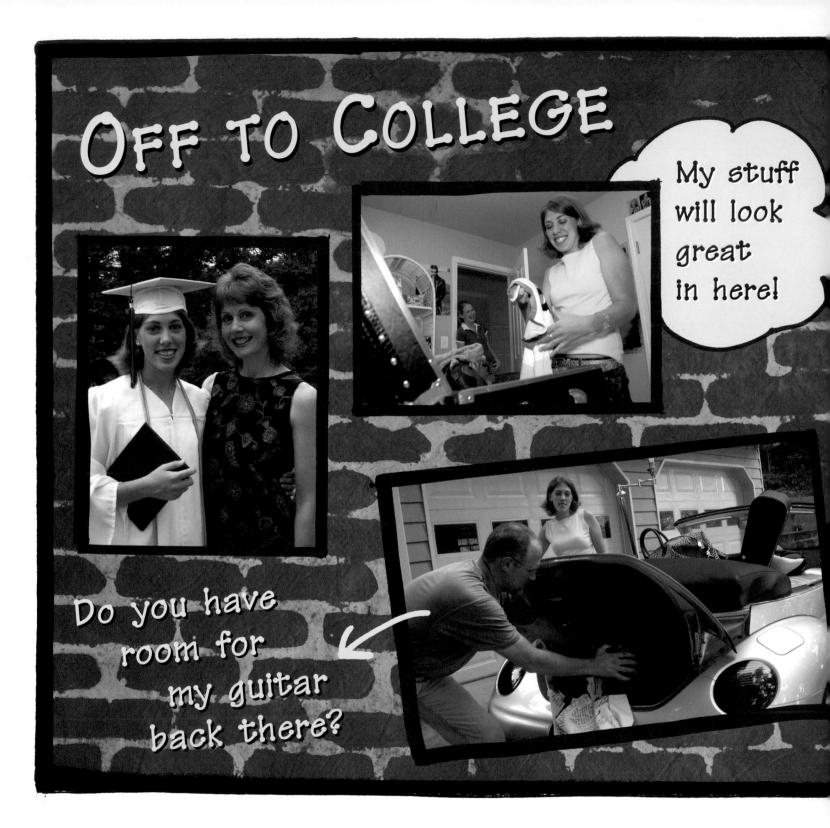

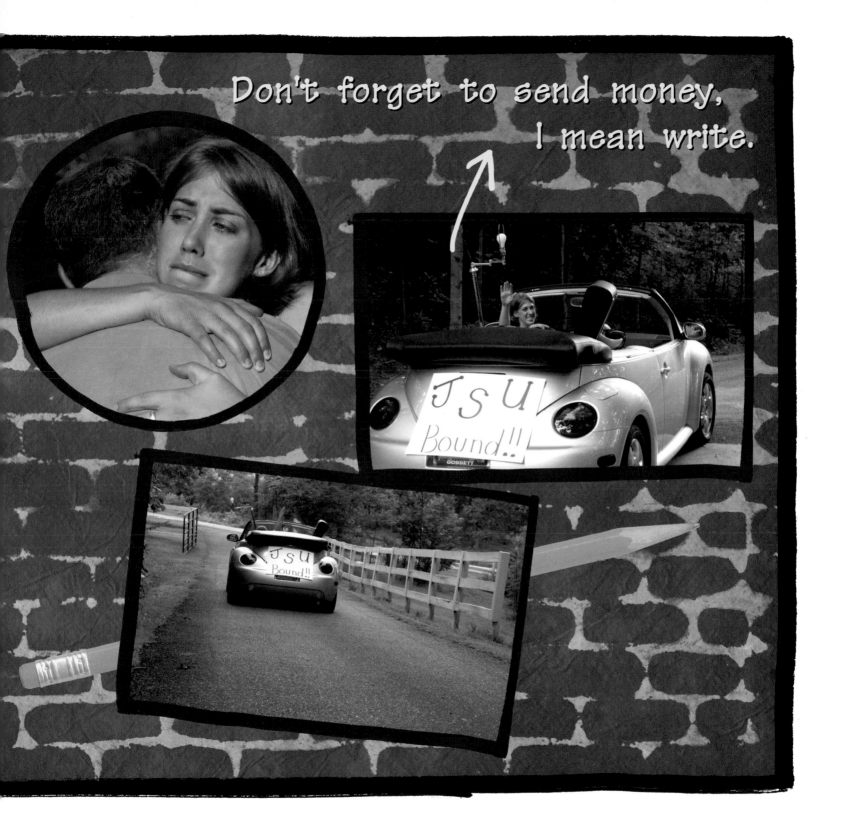

Expecting...

you say what's in there?!

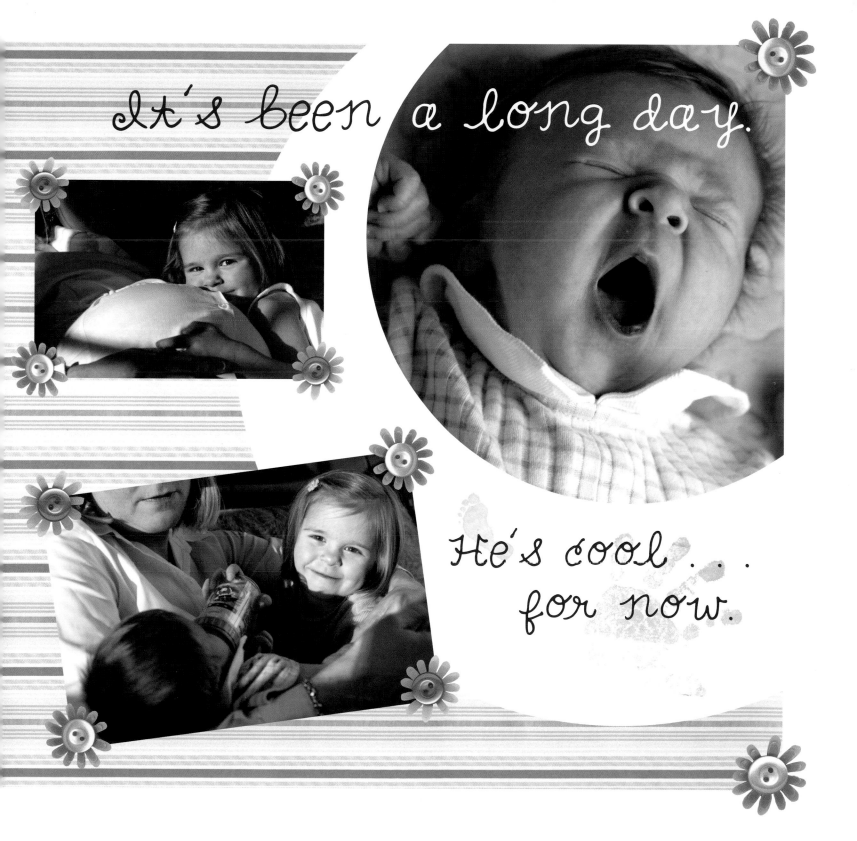

It's been a long day.

He's cool . . . for now.

Holiday Baking

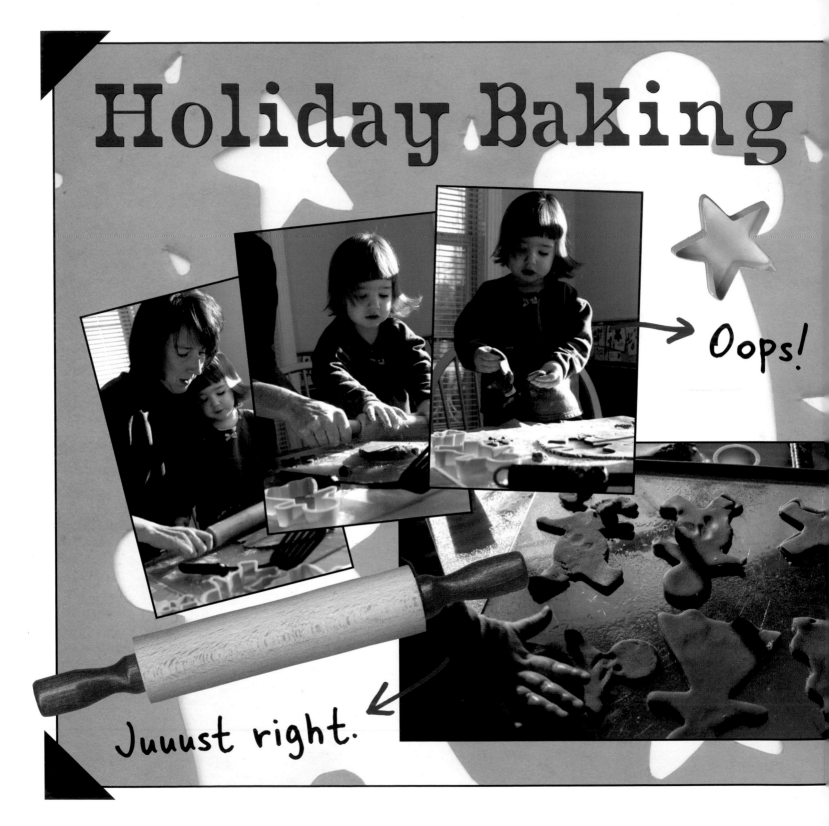

Oops!

Juuust right.

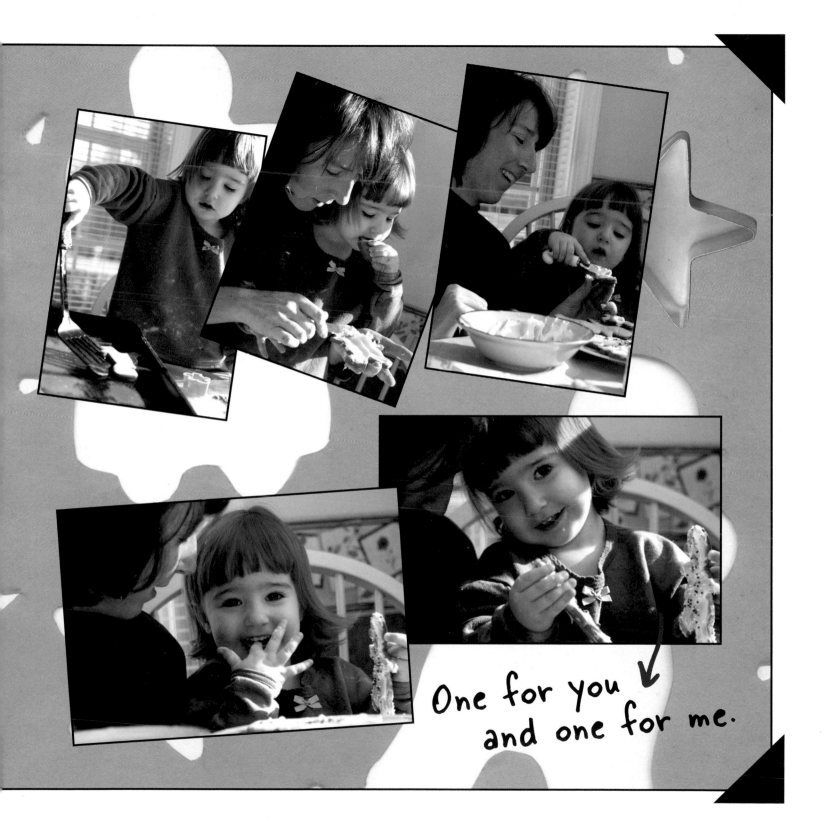

One for you
and one for me.

▸▸ Index